Beth Van Hoesen

Works on Paper

Beth Van Hoesen

Works on Paper

Foreword by Robert Flynn Johnson
Essay by Richard Lorenz

Chronicle Books
San Francisco

John Berggruen Gallery

Printed in Hong Kong

ISBN: 0-8118-1005-4

Library of Congress Cataloging-in-Publication Data is available.

Design and production by Marquand Books, Inc., Seattle, and Mark Adams
Essay edited by Suzanne Kotz
Copyedited by Pamela Zytnicki

We gratefully acknowledge permission to use an excerpt from Robert Flynn Johnson's essay
(copyright © 1983 by Robert Flynn Johnson) in *Beth Van Hoesen: Paintings, Drawings, and Prints*
(1983): p. 5. © 1983 by Beth Van Hoesen.

Front cover: *Pocketbook Vase*, 1991 (page 42)
Back cover: *China Dolls*, 1991 (page 85)

Reproductions in this book are from photographs taken by M. Lee Fatherree, except
the following: page 71: Dan Wagner, New York; page 89: Photo Services, The Fine Arts
Museums of San Francisco

Distributed in Canada by
Raincoast Books
8680 Cambie Street
Vancouver, B.C. V6P 6M9

10 9 8 7 6 5 4 3 2 1

Chronicle Books
275 Fifth Street
San Francisco, California 94103

Foreword

Beth Van Hoesen has her way with line . . . One might say that Dürer would have understood and approved, but one might equally compare it with Picasso. However, any comparison would only serve to point out the individuality that is here before us. Here is a style, and also an approach to subject matter so sensitive and intimate, and yet so direct and natural, that the artist need not use a signature to mark her works.

—E. Gunter Troche, 1961

The words quoted above by my predecessor at the Achenbach Foundation for Graphic Arts are evidence that the admiration for the art of Beth Van Hoesen began over twenty years ago and has continued unabated to the present day. Other talented artists during this time have burst like fireworks upon the art world of the Bay Area only to momentarily glow brightly and then quickly dim. Van Hoesen has had her graphic art shine like a steady glowing beacon over the years. Her art has grown and become increasingly rich and complex in its subject matter and color. This growth has come about through the methodical development and increased confidence of the artist, not through any outside pressures to succeed or be accepted.

Her art is based on line; it is the most direct, and also one of the most difficult ways to convey ideas artistically. In line, there is no place to hide. Her compositions are straightforward and, although carefully composed, still obtain a sense of spontaneity. Pleasing surface effects are not her purpose; composition, distillation of subject matter to its essential structure and insight into personality are her purpose.

—Robert Flynn Johnson, 1983
Curator in Charge
Achenbach Foundation for Graphic Arts
The Fine Arts Museums of San Francisco

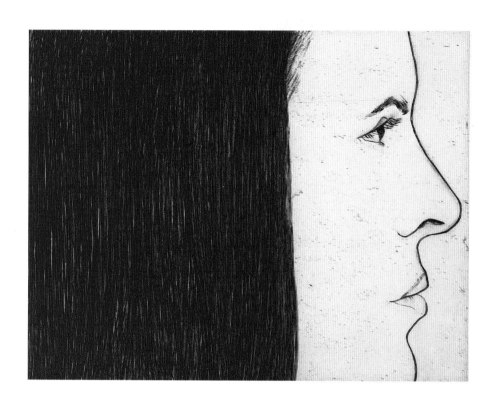

Profile

1960

Beth Van Hoesen

The Art of Observation

I admit nothing but on the faith of the eyes.

—Francis Bacon[1]

An affirmation and delight of life and its nuances are clearly visible in the art of Beth Van Hoesen—a contemplation of whatever her eyes behold. In the act of interpretation, she translates real form into her unique style. Her point of view, as one critic acknowledged, is "nonjudgmental, although not dispassionate."[2] Her various media—drawing, in pencil, ink, colored pencil, or watercolor, and intaglio printing—all rely on the truthfulness of her lines.

Van Hoesen prefers to see and feel, not to analyze. Political turbulence, social injustices, and pathetic imagery do not belong to her celebrations. Van Hoesen's purpose is clear to herself—a desire to observe and describe choice, transitory elements of the world. She makes no attempt to obfuscate her imagery with a symbolic spirituality like Morris Graves, to reinforce it with a Pop sensibility like Wayne Thiebaud, or to validate it by enlarging it to billboard proportions like Alex Katz. Van Hoesen's direct renderings will always prove the existence of a time and a place, a specimen, a personality, a trait she saw with her eyes, the miraculous windows through which she has perfected her extraordinary art of observation.

▾ ▾ ▾

Beth Van Hoesen was born in Boise, Idaho, in 1926. Her father, Enderse Van Hoesen, was the son of David Van Hoesen, a lawyer from upstate New York. The senior Van Hoesen in 1914 purchased the largest independently owned orchard in the United States with the idea of creating a family business for his two sons, Enderse and Mynderse (page 44). David became a prominent Idaho state senator whose expected governorship was precluded by his untimely death. Enderse left Williams College to attend the University of Idaho and study agriculture. Upon his father's

death, Enderse took his seat in the state senate and managed the apple business with Mynderse. Beth's mother, Freda Soulen, was raised in Moscow, Idaho. She met Enderse while they were students at the University of Idaho. A classical violinist, Freda was on the verge of a successful professional career before her marriage.

Beth Van Hoesen was raised in Mesa Orchards, Idaho, where the family apple orchards and processing plants were the major industry. Even though she was the boss's daughter, Van Hoesen remembers fitting in comfortably with the apple-pickers' children at the local one-room schoolhouse. It was during these years that her urge to draw spontaneously emerged. She routinely made pencil sketches of the world around her, and learned to discern the diversity of physical attributes she found in people and things. "I don't remember making a decision to be an artist," she states. "I just *was* one."[3]

During Van Hoesen's childhood, her mother suffered an extended illness and eventually moved back east to live with her sister in Greenwich, Connecticut. Beth's environs shifted from rural life in Idaho to a privileged life in Connecticut, where she attended Rosemary Hall, a Greenwich preparatory school. After the orchard business failed in the Great Depression, her father held numerous jobs in Boise, and in 1940 the family moved to Long Beach, California. Because of her fragmented education (she changed schools fourteen times), Van Hoesen received little formal art instruction, but she regularly practiced her draftsmanship from the life around her, and sometimes from illustrated books and magazines. In 1941 she almost died from peritonitis, and during her long and lonely recovery, she worked at her drawing.

Van Hoesen first worked in oils under the guidance of a neighbor who was a California desert painter. A believer in learning from imitation, he suggested that Beth copy Thomas Eakins's *Portrait of Walt Whitman* (1888) from a reproduction. The portrait was Whitman's favorite likeness of himself. He wrote: "It gets me there—fulfills its purpose, sets me down in correct style, without feathers, without fuss of any sort. I like the picture always—it never fades or weakens. It is not perfect, but it

comes nearest being me."[4] Van Hoesen found the exercise to be quite satisfactory: "When I look back, I realize that I learned a great deal from copying—studying a painter by looking at each brush stroke. One of my favorites, Degas, also learned from copying in museums."[5]

After graduation from David Starr Jordan High School in Long Beach, Van Hoesen entered Stanford University in 1944. There she studied painting with the Russian émigré Victor Arnautoff, who had been an assistant to Diego Rivera before himself becoming one of San Francisco's influential mural painters of the 1930s. For a project funded by the New Deal's Public Works of Art Project, he created *City Life* (1934), an important fresco in San Francisco's Coit Tower. Arnautoff taught Van Hoesen to observe accurately and to render with precision. Van Hoesen credits another Stanford instructor, Dan Mendelowitz, chairman of the Art Department, for instilling in her an enthusiasm and passion for art and art history.

During her years at Stanford, Van Hoesen spent six months in Mexico at the Escuela Esmeralda where she learned to temper her powers of observation with humanity, to see "not only with your eyes, but with your heart."[6] She also took summer courses in 1946 and 1947 at the California School of Fine Arts (now the San Francisco Art Institute). As a developing realist artist, she was confounded by Clyfford Still, the legendary abstract painter, and found his orations difficult and uninvolving. Another CSFA course, line drawing taught by David Park, was a more positive experience. Park, like Van Hoesen, fought the onslaught of the obligatory abstract expressionist style during the late 1940s. He, in fact, in an act of exorcism, destroyed four years' worth of his abstract paintings before returning to figure painting in 1949.

After graduation from Stanford, Van Hoesen spent two-and-a-half years in Europe. Based much of the time in Paris, she studied and drew from life at several art schools, including the Académie Julian, and frequented museums where she soon identified her favorite artists. Rembrandt in particular excited her, as did Antonello de Messina, Giovanni Bellini, and Piero della Francesca. She was especially interested in works

on paper by Dürer, Holbein, Ingres, Degas, and Matisse. She painted portraits of American tourists and eked out a subsistence living. A portrait from the time of a female model, *Concierge* (ca. 1949, page 11), is a charming rendering of period makeup and comportment.

In 1951 Van Hoesen returned to San Francisco, intent on establishing herself as a self-supporting professional artist. She enrolled at the CSFA again to study with David Park, and soon found that the fastidious working techniques she had developed in Europe had to be redirected. She recalled: "I must have seemed like a misfit when I entered David Park's painting class, sat up close to the model, and took out my little bottles of boiled oil, my hand-ground paints, and my small wood panel, gesso-grounded and sandpapered."[7] Although Van Hoesen continued to paint realistic figures, Park encouraged her to be looser, to concentrate on interpretation over representation, and to solve compositional problems of pictorial space. He once told her, "Beth, you have to swear more in your painting."[8] She became adept at painting models in which she cropped the figure and paid attention to the spaces between arms and legs. Park made an appropriate statement that allowed her to move on: "As you grow older, it dawns on you that you are yourself—that your job is not to force yourself into a style but to do what you want."[9] Painterly brushstrokes and thick oils were not for her; she took what she learned from Park, however, and synthesized it accordingly.

A variety of odd jobs helped Van Hoesen support herself during the early 1950s. She answered the telephone for Arthur Murray's guess-a-tune radio contest, and she worked as a hostess at the Shadows, a German restaurant next door to her home on Telegraph Hill. She also began to sell the pen-and-ink portraits and drawings of buildings and gardens she had made in Paris. In 1952 she showed a collection of these drawings in her first solo exhibition at the Lucien Labaudt Art Gallery in San Francisco. A client, unsure of which of her drawings he should purchase, asked another struggling artist-friend named Mark Adams to aid his decision. Adams had studied in New York with Hans Hofmann, the abstract expressionist painter known for his theories of color and space, and one

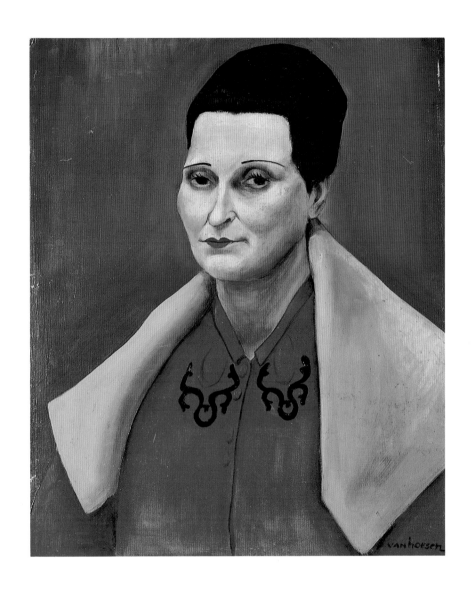

Concierge

ca. 1949

of the country's preeminent painting teachers. Van Hoesen, in fact, was considering a trip east to study with Hofmann, but Adams offered to pass on what he had just absorbed from the master. Over the course of their sessions, they fell in love, and they married in 1953.

Van Hoesen's interest in painting gradually faded during the 1950s as she honed her skills in printmaking. She had studied etching at the CSFA as early as 1951 and, in the later 1950s, took additional courses in new printing methods from John Ihle, a master intaglio printmaker who taught at San Francisco State College. Van Hoesen loved the particular nuance of the intaglio print; the incised line of engravings and the soft fine line of drypoint produce effects that no simple drawing can equal.

If Van Hoesen had selected a difficult and relatively esoteric art form for her métier, Mark Adams chose an even more demanding and inaccessible one: Aubusson tapestry. In 1955 Adams, accompanied by his wife, traveled to Saint-Céré, France, to apprentice for three months with Jean Lurçat, a pioneer of modern tapestry. Van Hoesen assisted on Lurçat's cartoons by blocking out the designs with numbers for colors. It was, in a way, to her liking because the preliminaries involved line drawing. She was also happy to draw from nature in the French country-side. The trip became a tour of Europe during which the couple traveled in Italy, Spain, and North Africa, comparing notes on likes and dislikes in every museum they visited. Van Hoesen says, "It was like having two sets of eyes!"[10]

Van Hoesen's early black-and-white prints emphasize representation and composition, precision and clarity. Chiaroscuro is avoided in favor of a flat, oriental light. Perhaps one of her oddest and most engaging etchings of the 1950s is *Yearbook* (1958, page 13), a prescient example of her synthesis of still life and portraiture. In this instance, she straddled the line between truth and invention by adapting the traditional academic format, full of fresh, smiling faces, to include, among others, *San Francisco Chronicle* art critic Alfred Frankenstein, Stanford classmate and author Evan Connell, and husband Mark Adams. A truncated self-portrait etching, *Profile* (1960, page 6), is a marvelous example of her occasionally

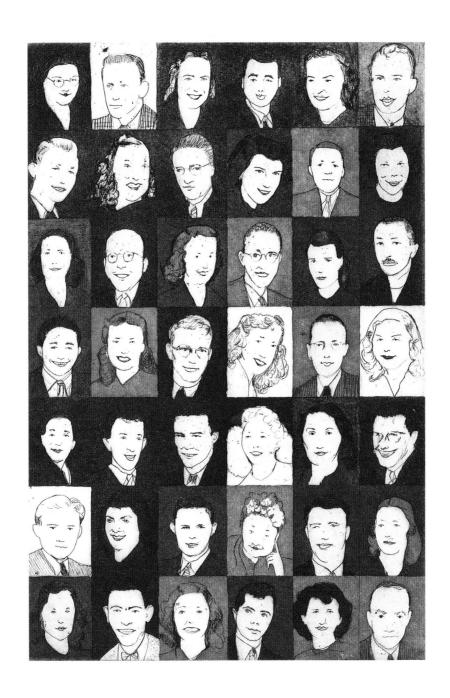

Yearbook

1958

daring cropping. The print becomes a diptych of balanced but opposite minimalist spaces: one shimmering with dense, black vertical strokes, the other a flat box of white interrupted by an assured, linear profile.

Years of life drawing have contributed to Van Hoesen's interest in portraying the nude. In 1965 she published a portfolio, *The Nude Man*, that included twenty-five prints of men of different shape, age, color, and size. Unerotic and posed in decidedly nonclassical postures, Van Hoesen's real men lend an air of relaxed unpretension to these candid and extraordinarily detailed etchings and aquatints (*Back*, 1965, and *Seated*, 1965, pages 15, 16).

The act of observation and the subsequent translation of form and character onto paper have become routine for Van Hoesen. Her original drawings, loose and spontaneous, capture the spirit of the subject. "Drawing from reality," she notes, "my work became intuitive and interpretive. . . . [It] demands an absorbing concentration and takes you away from a self-conscious, arbitrary style into work that is really your own."[11] Thomas Albright, the late art critic for the *San Francisco Chronicle*, described her renderings neatly: "[They] follow the conventions of academic realism but are endowed with an undertone of quirky idiosyncrasy that grows largely out of a lively. . . line."[12] Drawings are, in a way, often more charged than the prints that might follow. Having been filtered and condensed through a good number of sketches and incarnations, the print is a formal statement, an example of the artist's distinct, signature style, that has passed through a fastidiously orchestrated production involving printing assistants and quantities of state proofs. Planning a print, Van Hoesen might make a dozen or more successive preparatory drawings "to achieve a good one in which a single flowing line expresses the whole form."[13] To her, the most important aspect of the process is to retain the feeling of spontaneity. Because a fraction of an inch within the area of the plate mark can make a noticeable difference, composition is critical, and Van Hoesen labors to perfect the relationship of object to background.

Van Hoesen became more interested in color during the 1960s when she began to combine watercolor washes with colored pencil drawings. She also became skilled in difficult color-printing processes such as

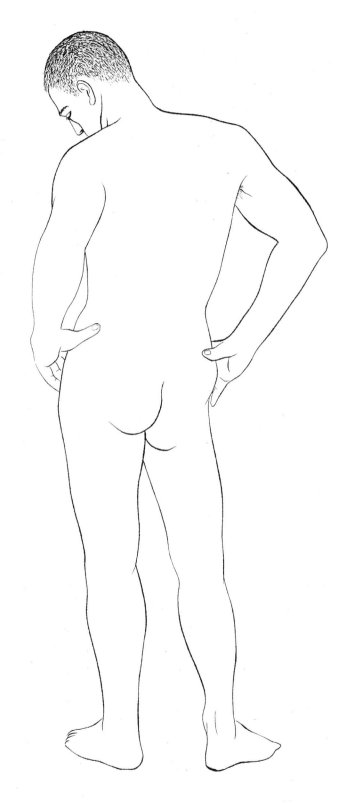

Back

1965

15

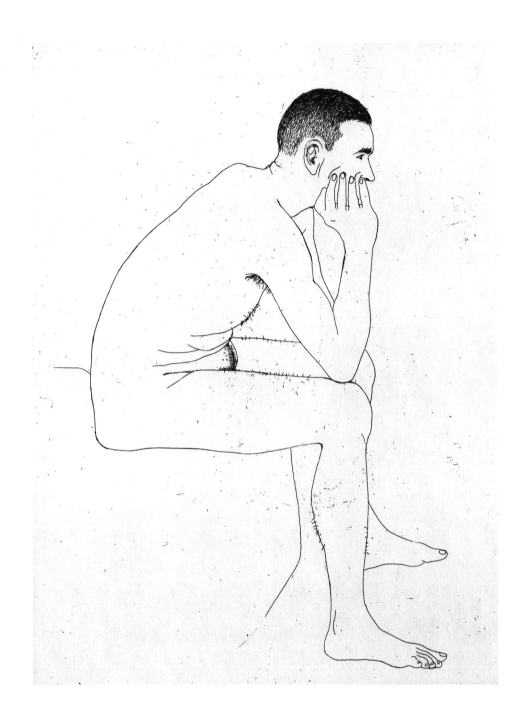

Seated

1965

inking *à la poupée,* in which she carefully mixed colored inks on one printing plate rather than using a separate plate for each color. Many of her best-known prints, such as *Sally* (1979, page 19) and *Dürer Can* (1982, page 46), have employed this exceptionally challenging technique.

Van Hoesen periodically referred to the landscape and exterior environments in her earlier art, but since the mid-1960s, portraiture of people and animals, and still lifes of dolls, comestibles, and flora have formed the core of her work. Her finely wrought impressions of people and what she calls "God-made things" make us consider the relationship between the portrait image and the nature of the original being. Van Hoesen's interpretations, as realistic as they seem, actually point beyond reality to those truths that she has felt and captured; we see attitude and posture and try to imagine a voice: Is the person Traci as interesting as the image *Traci* (1990, page 72)? We generally cannot know.

Van Hoesen's frequent representations of dolls—observations on silent observers—convey a sly knowingness. These colored pencil drawings of assembled inanimate personages have an edge (*China Dolls,* 1991, page 85). Their faces express emotions from silly, safe pleasure to sinister, schizophrenic charm. All eyes open, they stare and watch without analyzing or judging, recalling a poem by Margaret Atwood, part of which goes:

> A doll is a witness
> who cannot die,
> with a doll you are never alone.[14]

Unlike portrait sessions, where the artist's experience can be unique and exclusive, we can more easily and emphatically share common experience with many of Van Hoesen's other subjects. Tempting still lifes of cakes and confections trade on the viewer's connotations of smell, taste, and texture, and create a democratic sense of bonhomie. Her floral interpretations perhaps stir the most suggestive associations. Orchids, peonies, and roses jog subliminal memories of fragrance, funerals, Easter, mothers, courting. As Colette wrote: "Rose, increased in size, shrunk, perverted, disguised, docile in the fickle hands of men, you can still arouse and calm what remains in us of love's folly."[15]

Alternating between free-floating, descriptive renderings and more baroque, arranged, tabletop floral-pieces, Van Hoesen's drawings and prints of plant forms follow a rich tradition of botanical illustration. Her fascination with detail is obsessive, and she exhibits an astonishingly skillful precision in capturing the intricacies of botanical morphology on paper. Mindful of depicting the correct number of stamens on a lily, Van Hoesen is a patient and steady witness of life. Her attestations are selective, sometimes arranged, precisely composed, and always preponderantly real. Like the seventeenth-century Dutch painter Jacques De Gheyn, whose pictures frequently consider the representation of attentiveness,[16] Van Hoesen sincerely believes in the power and importance of observation. Thus in several arrangements incorporating reflective containers, we note Van Hoesen contemplating herself observing her subject, her visage ever watchful of the progressive revelations at hand.

▾ ▾ ▾

Artists have replicated the real world, in two and three dimensions, throughout the millennia. Although twentieth-century movements periodically decry realism as anachronistic (indeed, the invention of photography in 1839 first suggested the superfluity of realistic painting), its validity and an appreciative audience for its intelligent use will always exist. The keen selection, scrutiny, and interpretation of fragments of our world are richly continued in the art of observation, and with her formidable control of line and color, Beth Van Hoesen steadfastly refines this art. Her assured artworks are sublime accomplishments that seduce us with infinite pleasure, charm, and grace, qualities the world too often has in too little measure.

—Richard Lorenz

Sally

1979

Notes

1. Francis Bacon, "Great Instauration," *Works* (4:30), quoted in Svetlana Alpers, *The Art of Describing: Dutch Art in the Seventeenth Century* (Chicago: University of Chicago Press, 1983), p. 105.

2. Celeste Connor, "Beth Van Hoesen: The Art of Beholding," *Women's Studies* 22 (1992), pp. 96–97.

3. Beth Van Hoesen, *Beth Van Hoesen: Creatures, The Art of Seeing Animals* (San Francisco: Chronicle Books, 1987), p. 1.

4. Walt Whitman, quoted in Gordon Hendricks, *The Life and Work of Thomas Eakins* (New York: Grossman Publishers, 1974), p. 181.

5. Van Hoesen, p. 1.

6. Ibid.

7. Ibid., pp. 1–2.

8. Interview with Van Hoesen, December 1994.

9. David Park, quoted in Greta Berman and Jeffrey Wechsler, *Realism and Realities: The Other Side of American Painting 1940–1960* (Rutgers, N.J.: Rutgers University Art Gallery, 1981), p. 155.

10. Interview with Van Hoesen, December 1994.

11. Van Hoesen, p. 2.

12. Thomas Albright, *Art in the San Francisco Bay Area 1945–1980* (Berkeley: University of California Press, 1985), p. 319.

13. Van Hoesen, p. 98.

14. Margaret Atwood, "Five Poems for Dolls" (iii), in *Two-Headed Poems* (New York: Simon and Schuster, 1978), p. 18.

15. Colette, "Secrets," in *Flowers and Fruit*, ed. Robert Phelps, trans. Matthew Ward (New York: Farrar Straus Giroux, 1986), p. 100.

16. Alpers, p. 89.

Plates

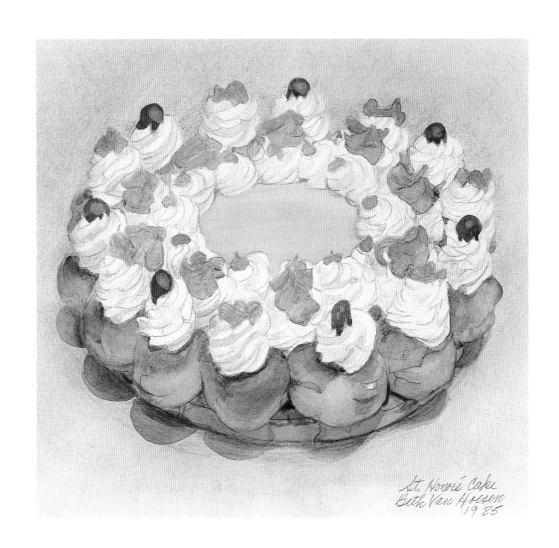

St. Honoré Cake

1985

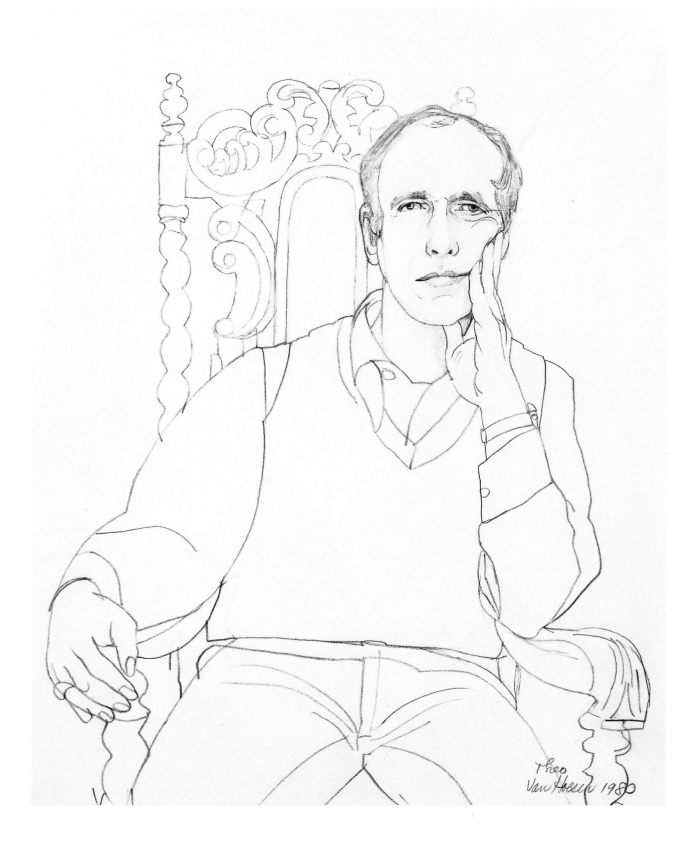

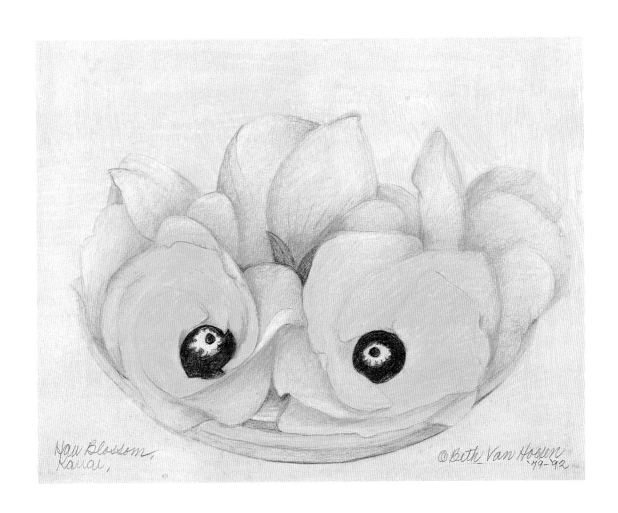

Hau Blossom,
Kauai,

©Beth Van Hoesen
'79-92

Theo

1980

Hau Blossom

1979/92

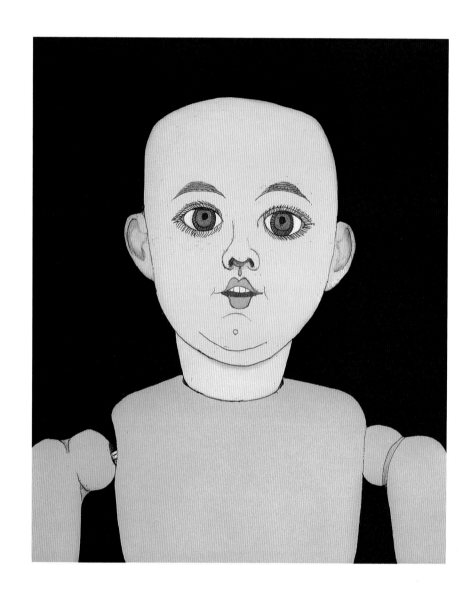

Jan's Doll

1990

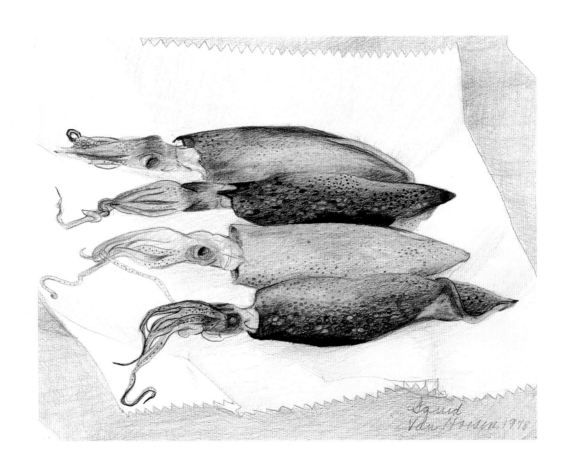

Squid

1978

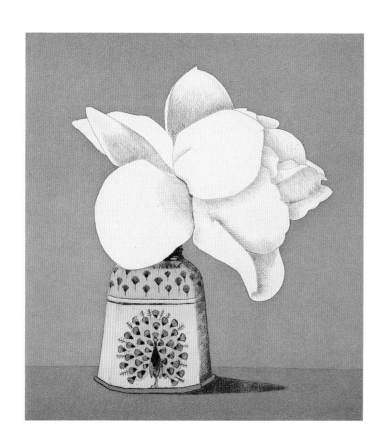

Sherwood's Rose

1982

28

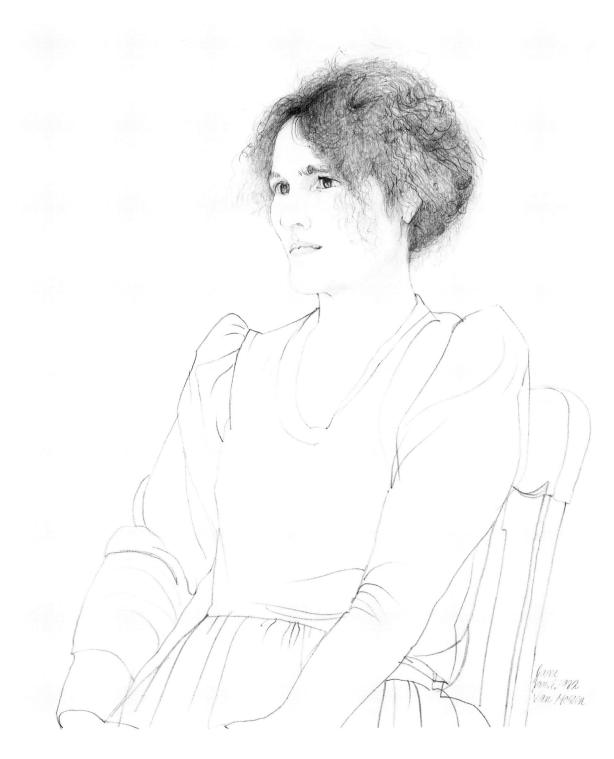

Jane

1982

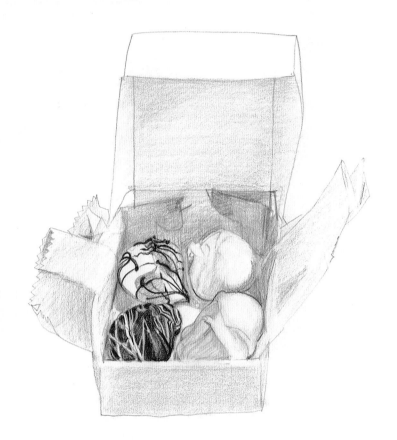

Chocolate Truffles

1982

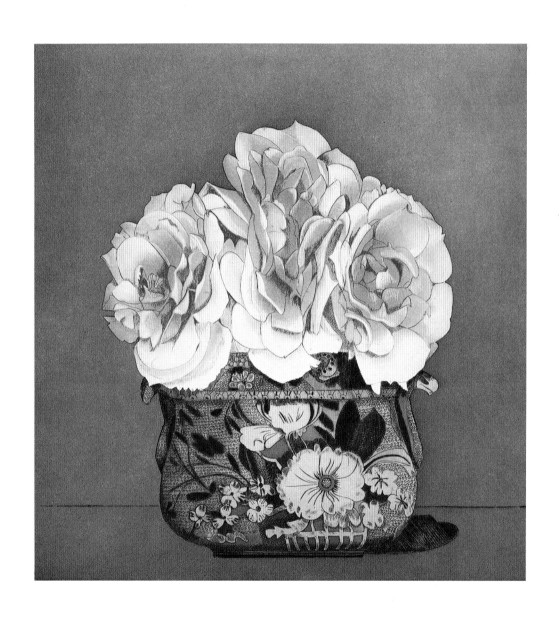

Bowl of Roses

1979

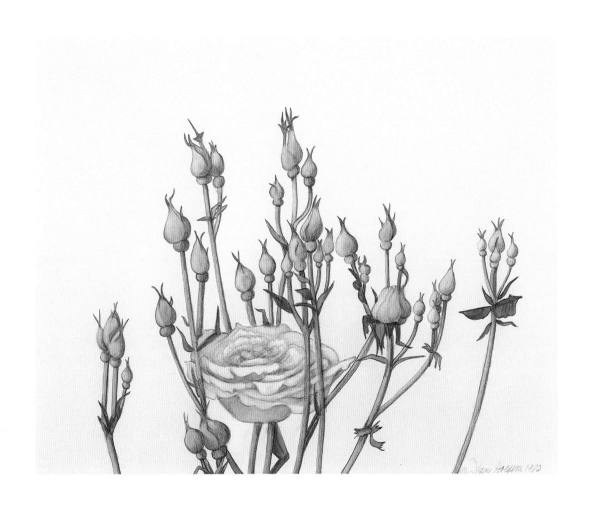

Filoli Rose

1980

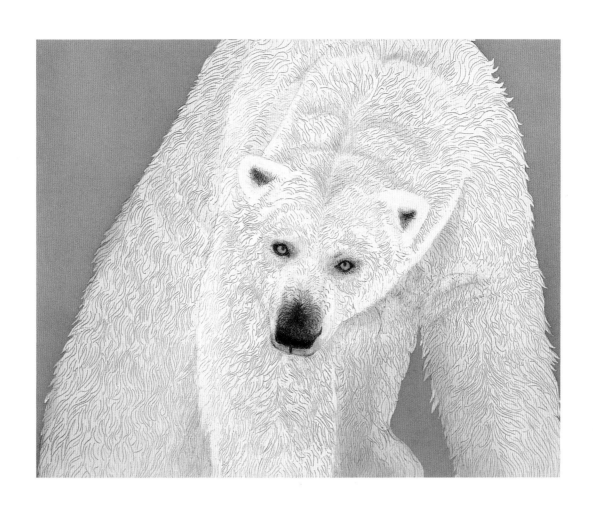

Pike

1988

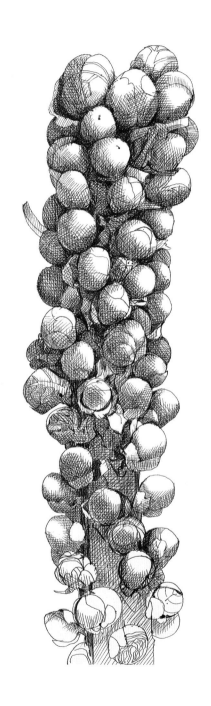

Brussels Sprouts

1980

34

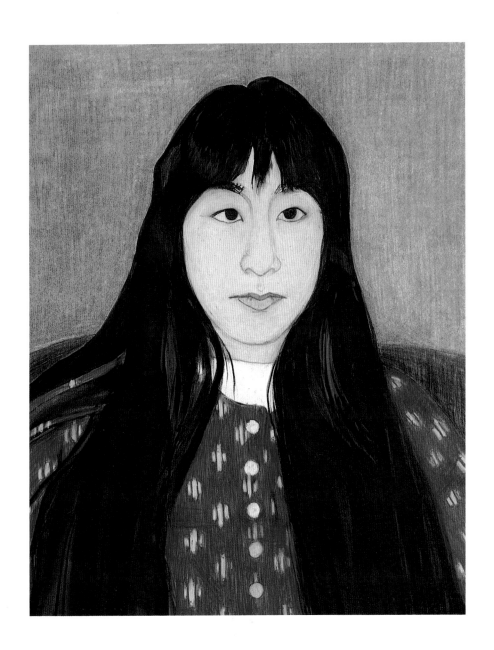

Michiko

1991

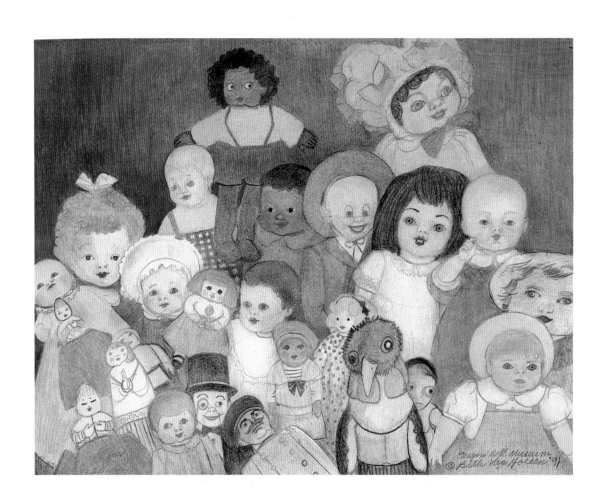

Oregon Doll Museum

1991

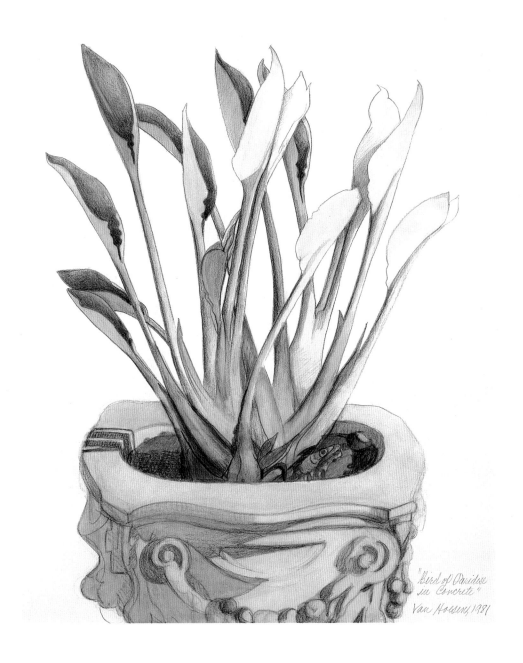

Bird of Paradise in Concrete

1981

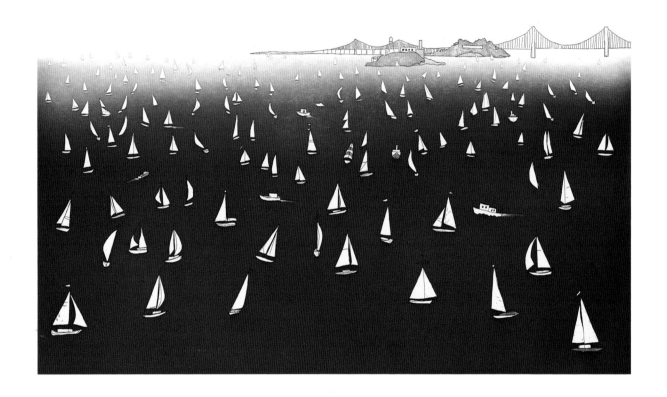

Bay Boats

1988

Heidi

1987

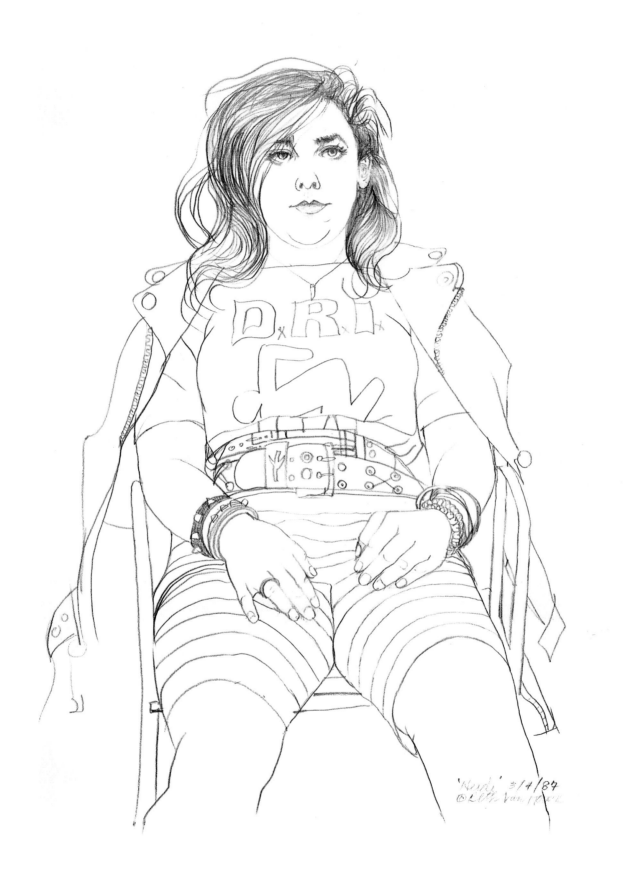

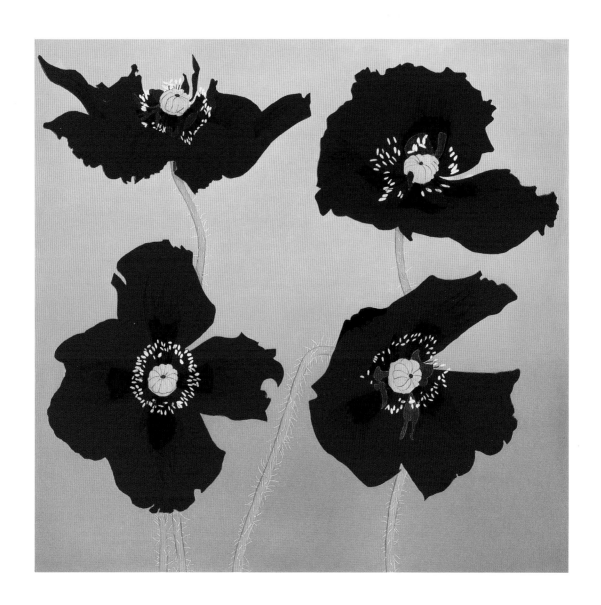

Albert's Poppies

1991

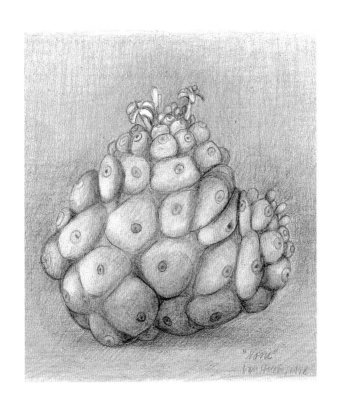

Noni

1978

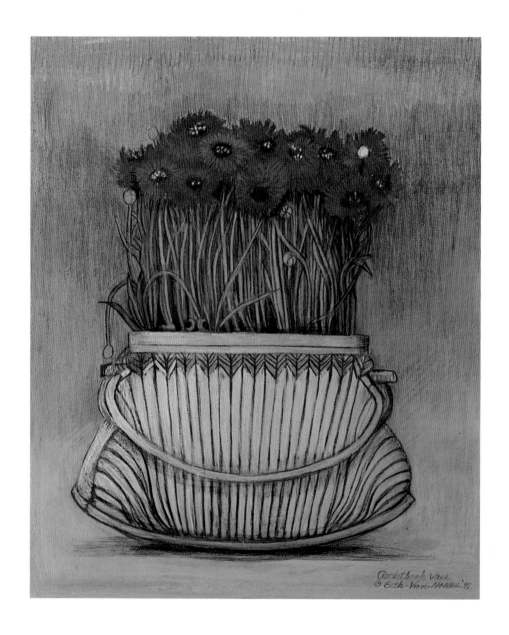

Pocketbook Vase

1991

Cold in Aswan

1964

42

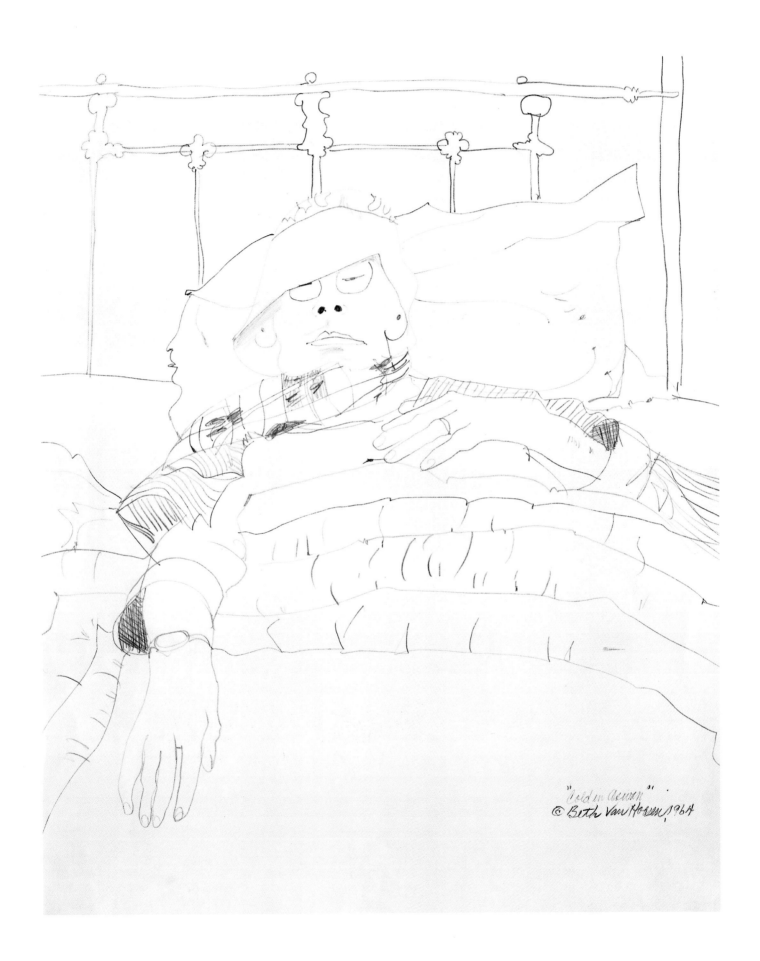

"Cold in Heaven"
© Beth Van Hoesen 1964

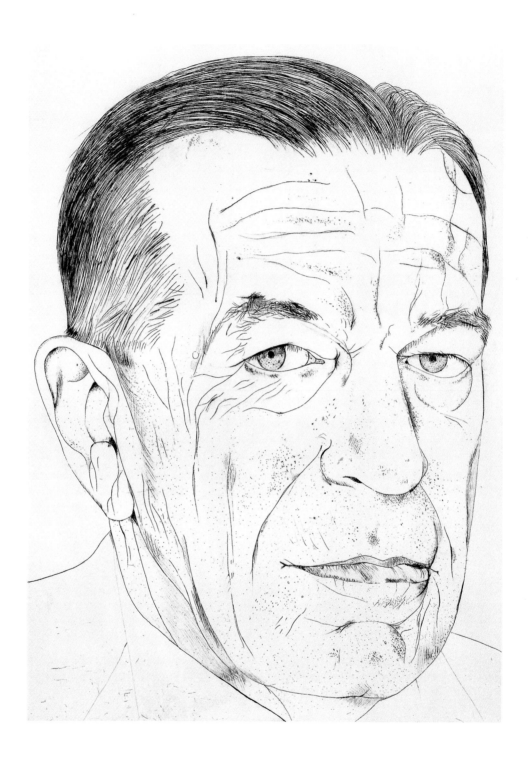

Mynderse

1968/80

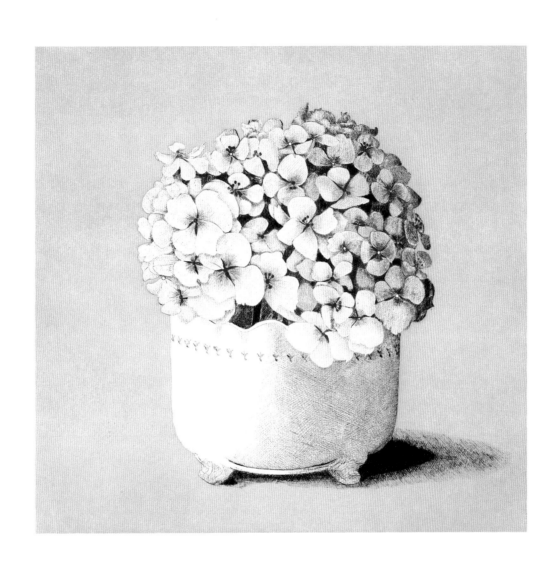

Bowl of Hydrangeas

1979

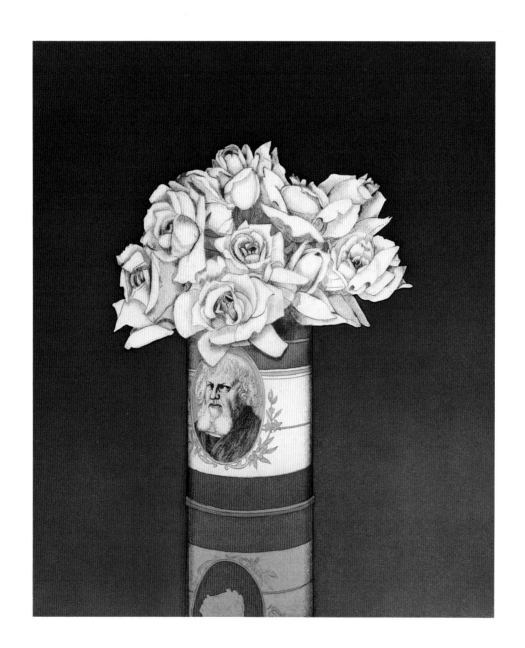

Dürer Can

1982

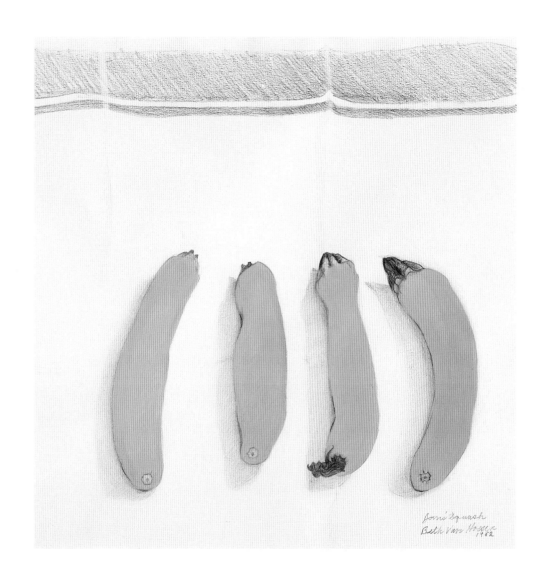

Jan's Squash

1982

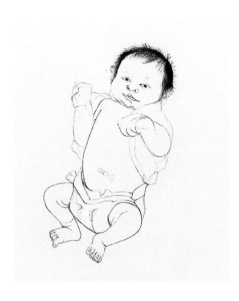

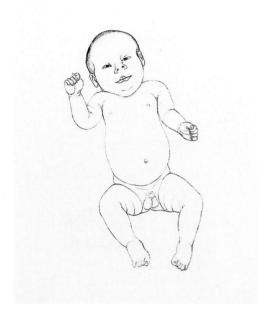

Baby Girl Young

1983

Baby Boy Eaton

1983

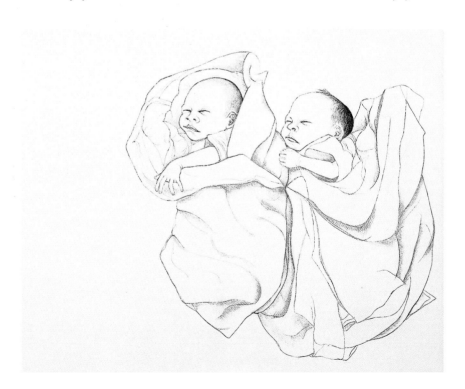

A & B Ferree

1983

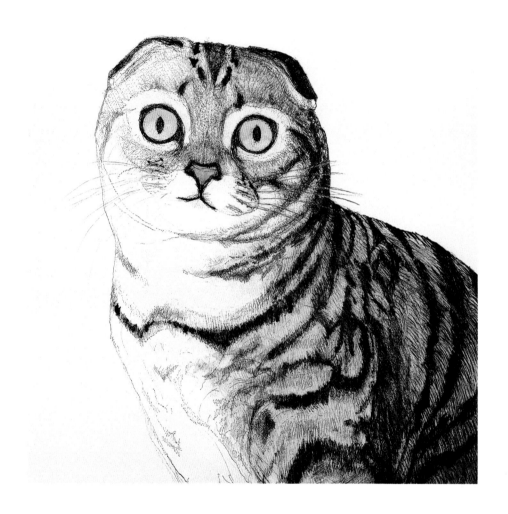

Matthew

1992

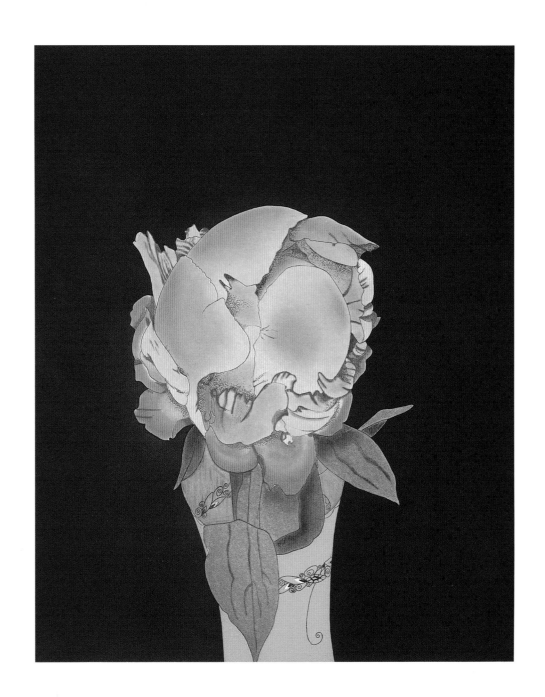

Peony

1975/76

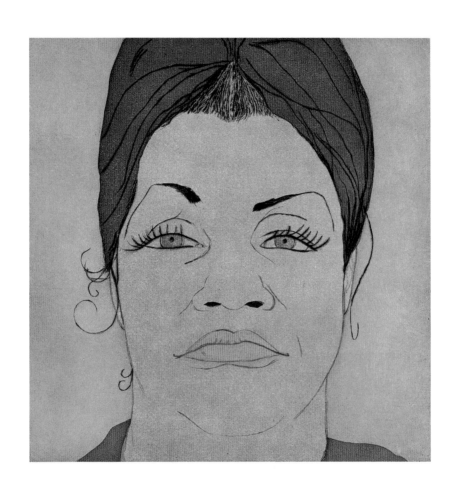

Flo

1973

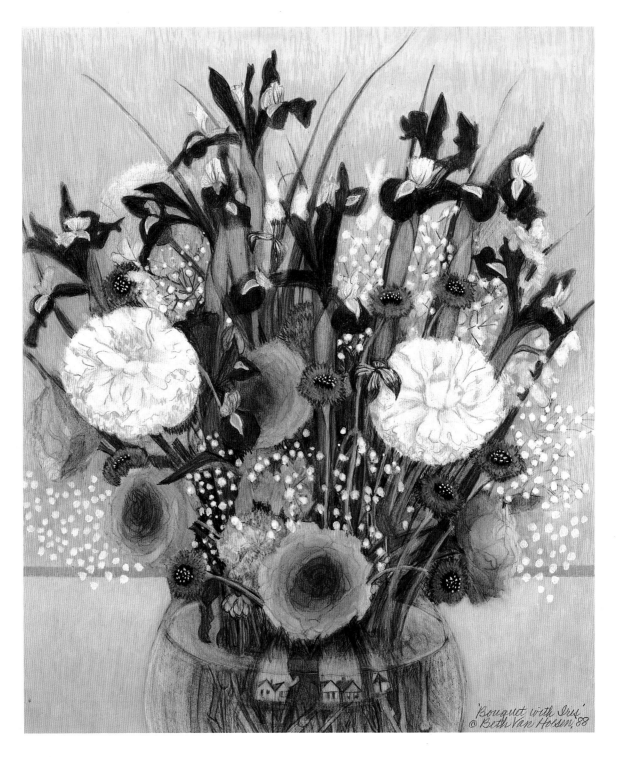

Bouquet with Iris

1988

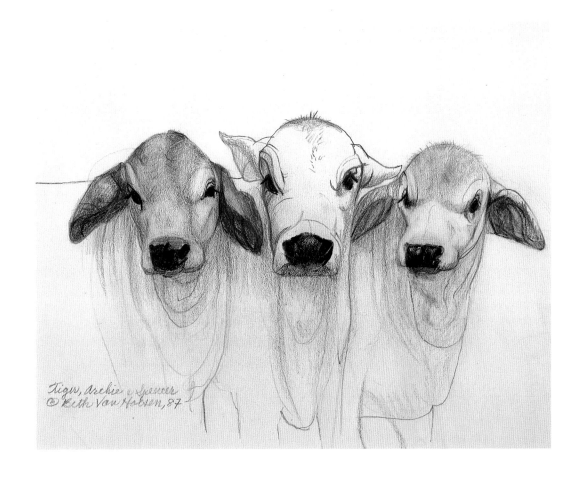

Tiger, Archie and Spencer

1987

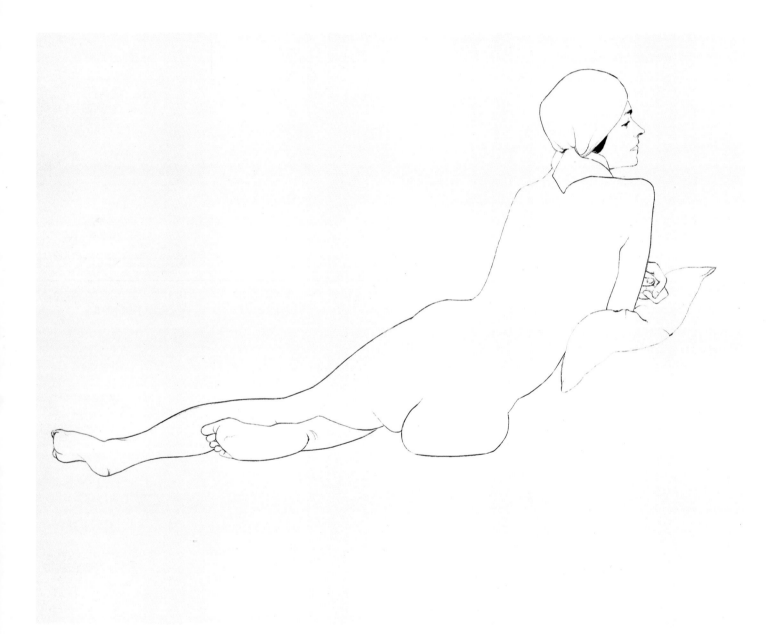

Sylvi

1978

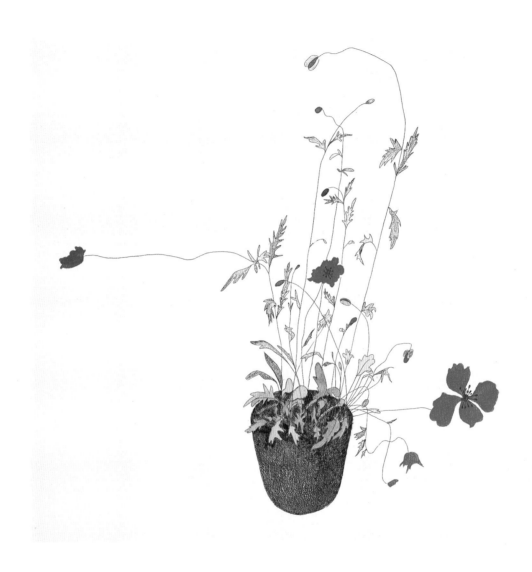

Little Poppies

1975/80

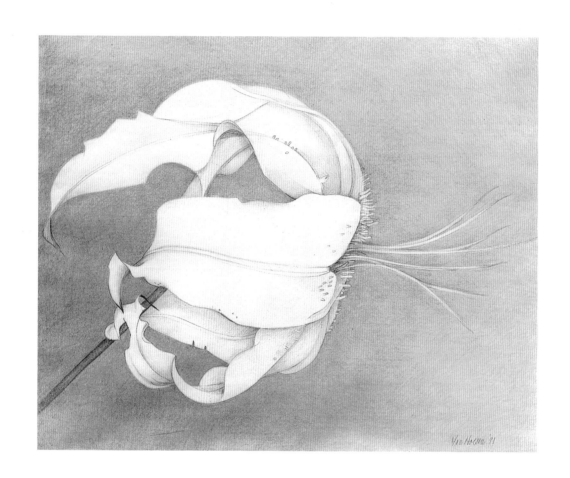

Lily

1981

Lisza

1982

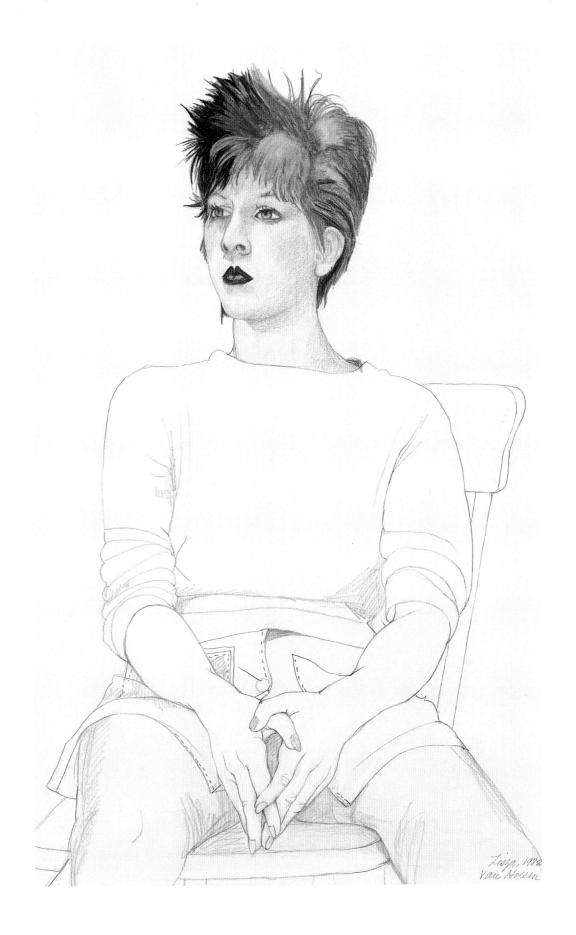

Liisa, 1982
Van Housen

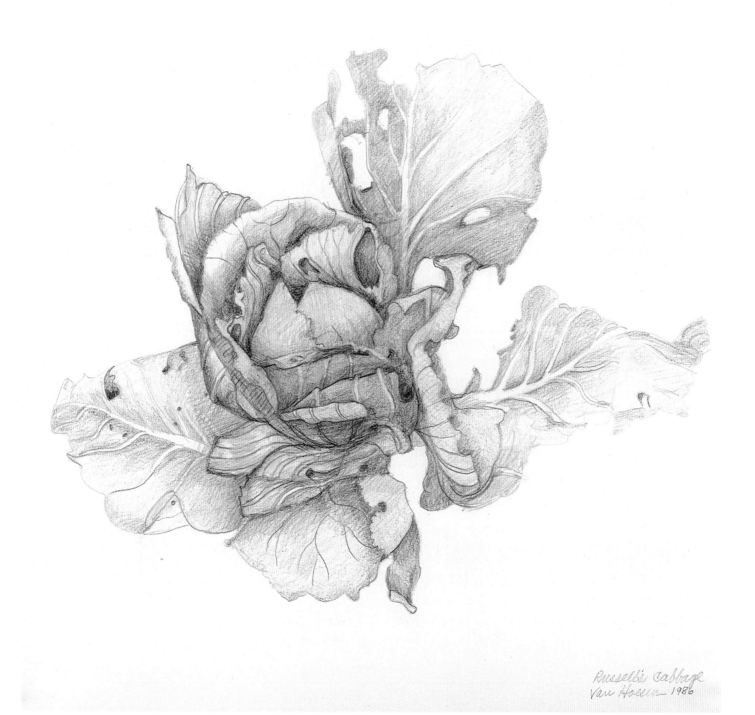

Russell's Cabbage

1986

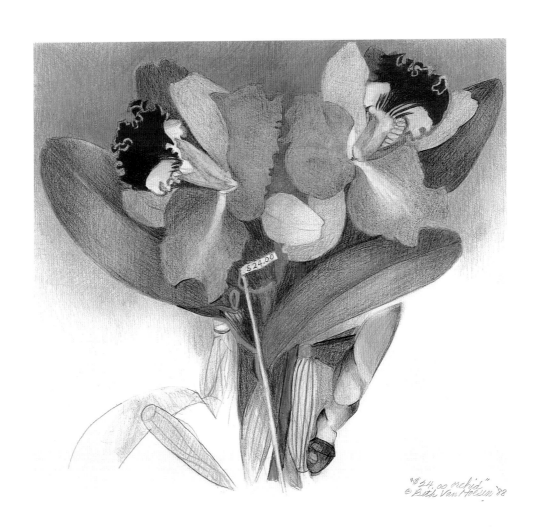

"$24.00 orchid"
© Beth Van Hoesen '88

$24 Orchids

1988

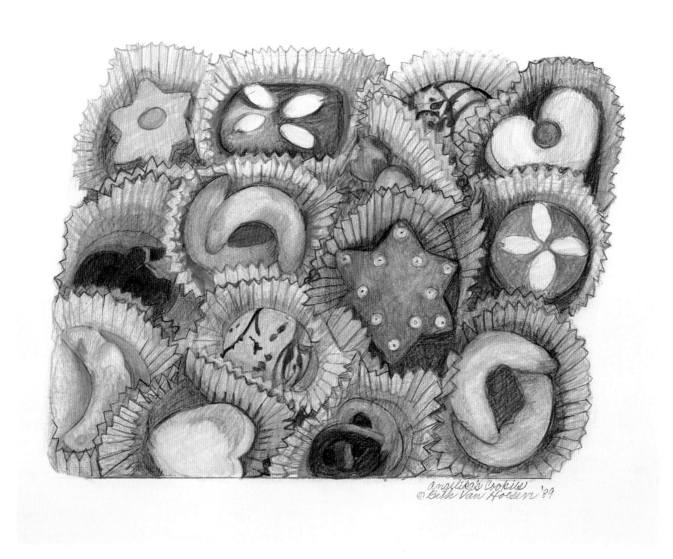

Angelika's Cookies

1989

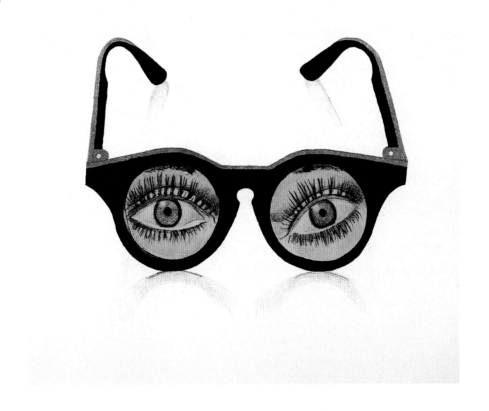

Hologram Glasses

1990

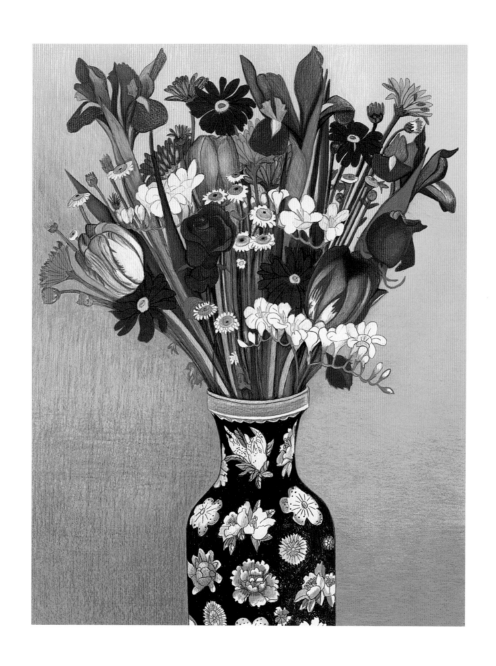

Flowers, Flowered Vase

1992

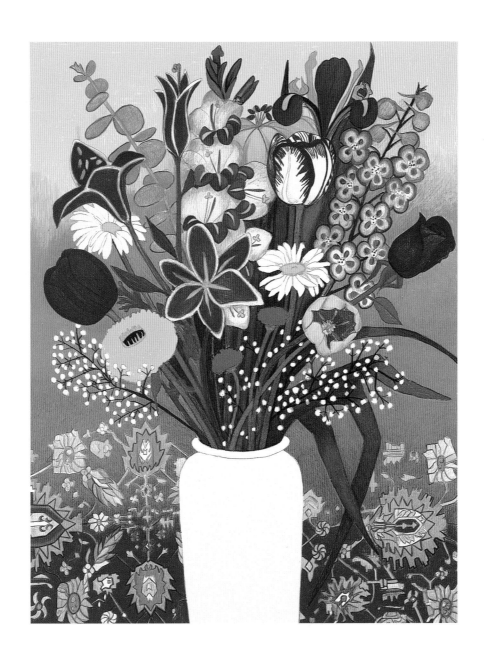

Flowers, White Vase

1993

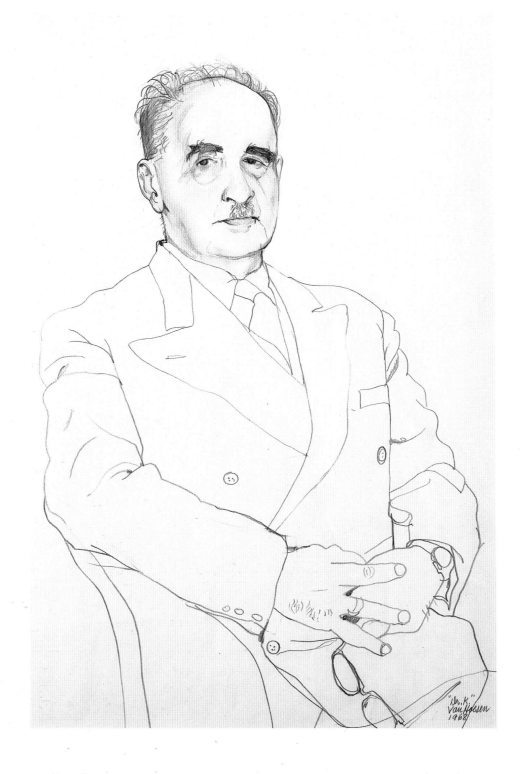

Dr. K

1968

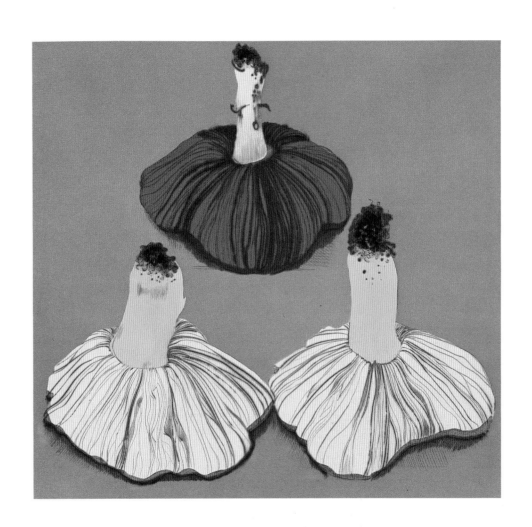

Fungi

1982

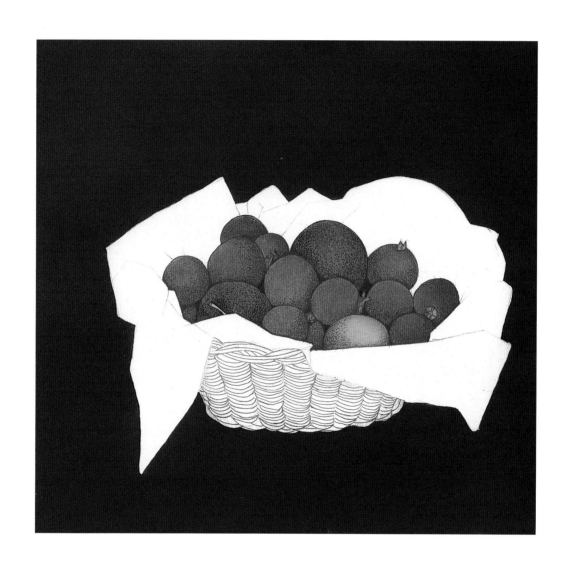

Fresno Basket, 2nd state

1984

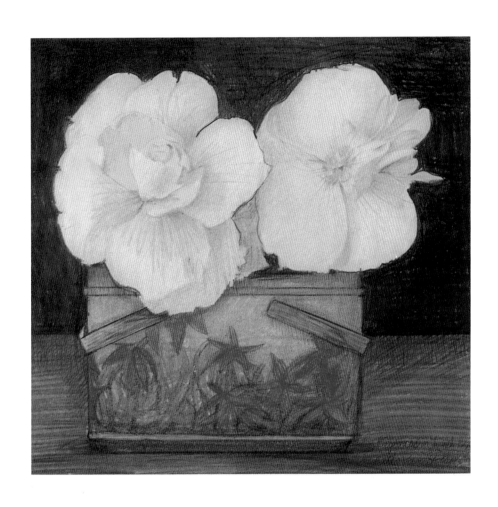

Begonias in Lunch Box

1991

Haemanthus

1990

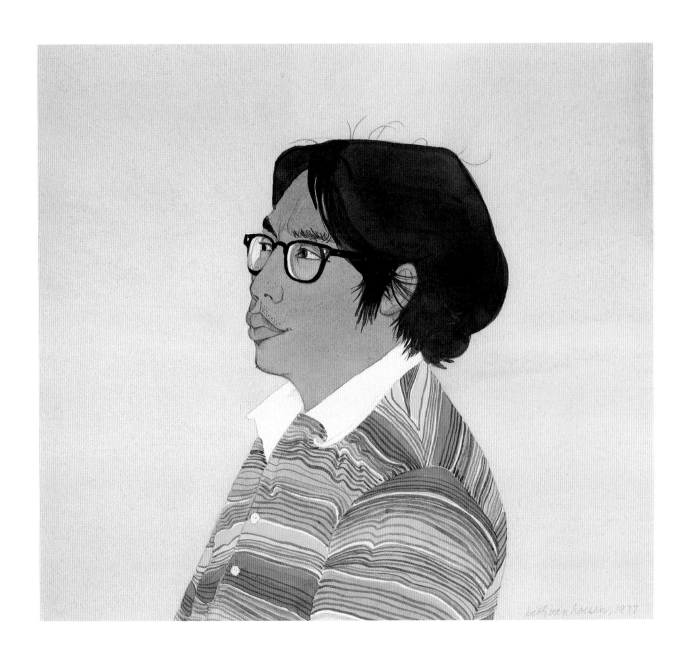

David S.

1977

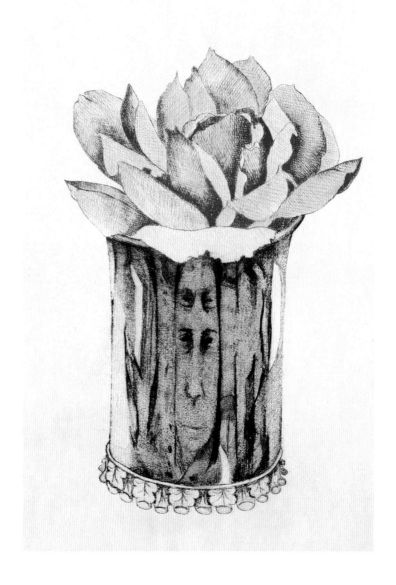

Silver Cup

1978

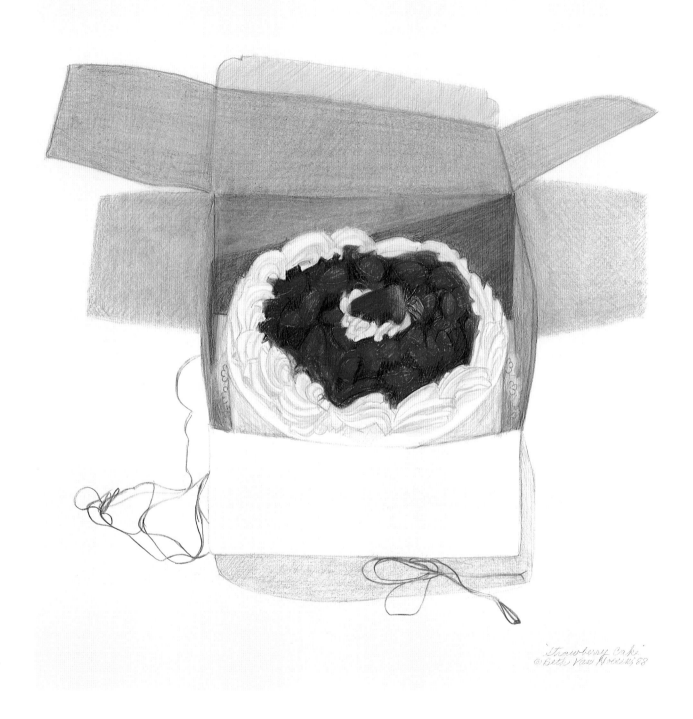

Strawberry Cake

1988

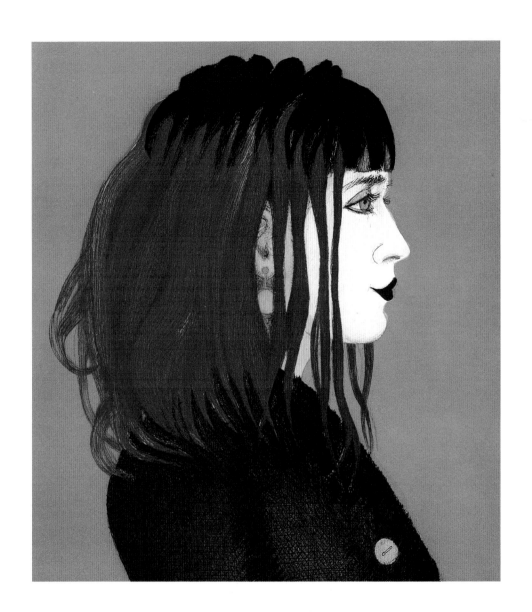

Traci

1990

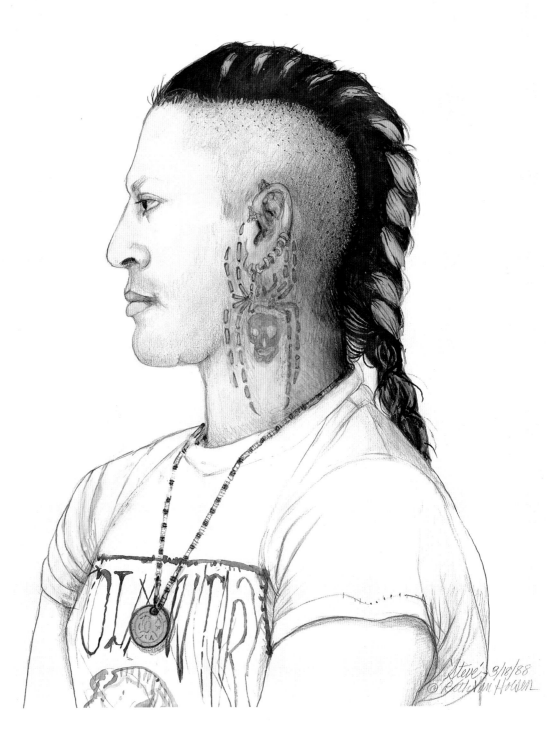

Steve

1988

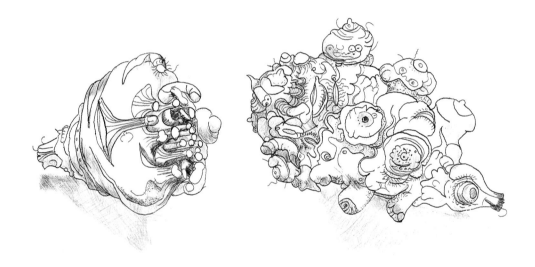

Edible Roots

1990

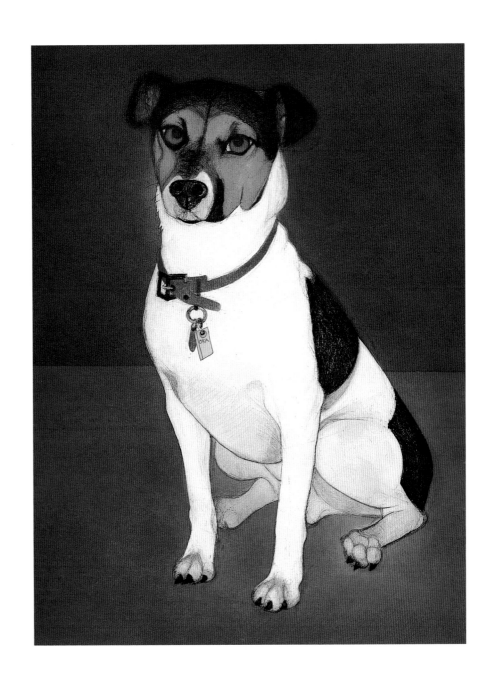

Oka

1991

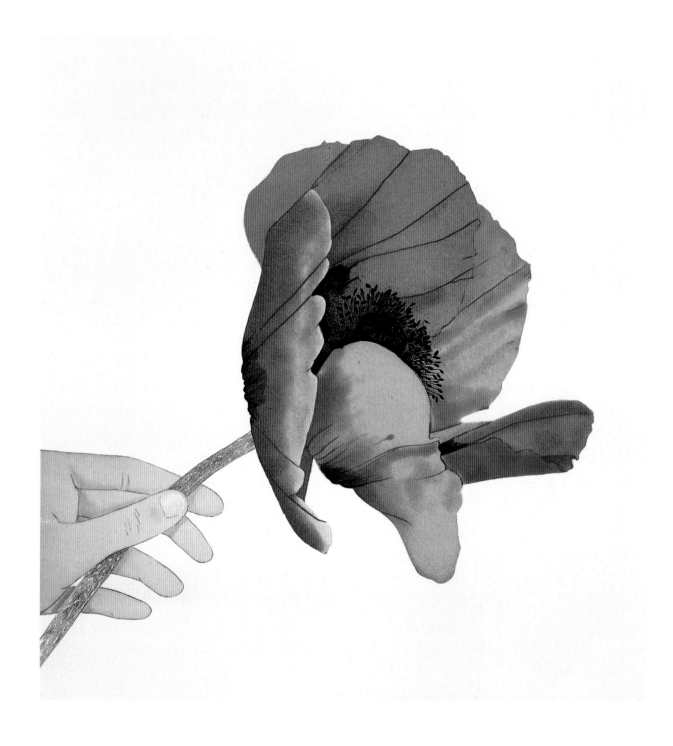

Poppy in Hand

1975/76

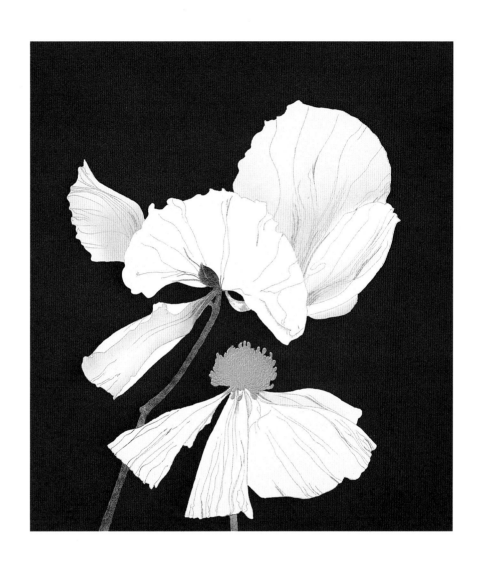

Matilija Poppy

1975/76

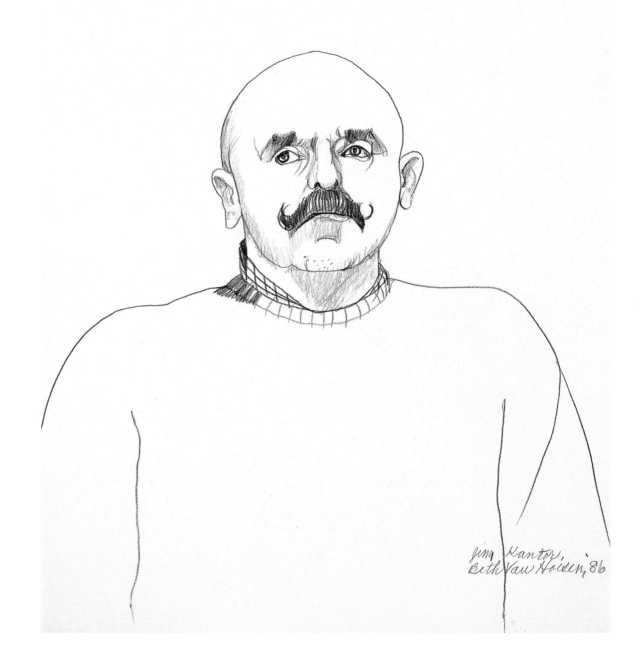

Jim Kantor

1986

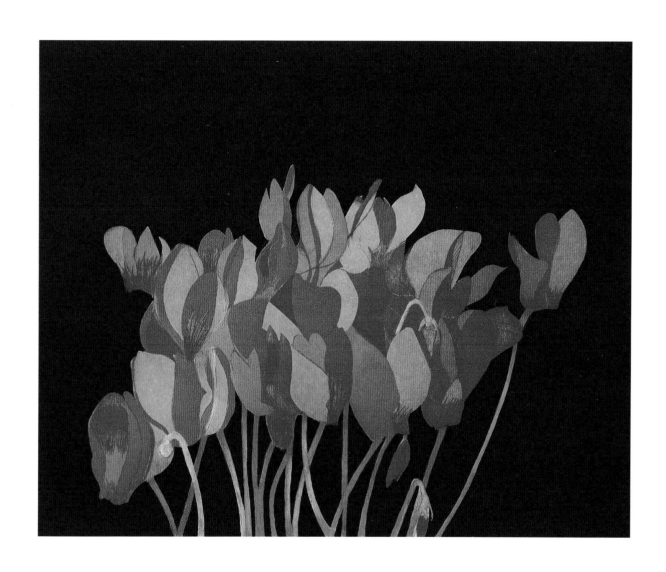

Park Cyclamen

1988

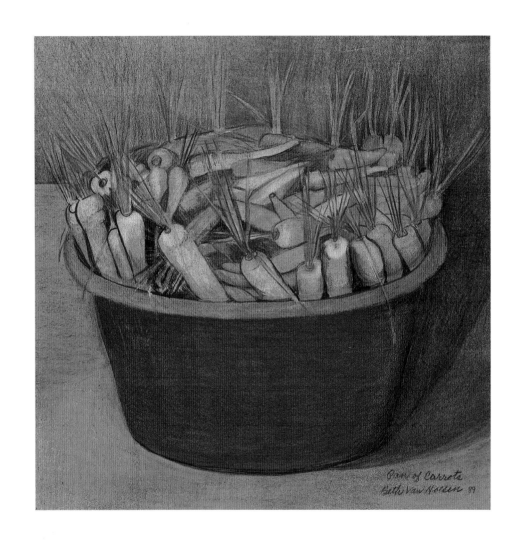

Pan of Carrots

1989

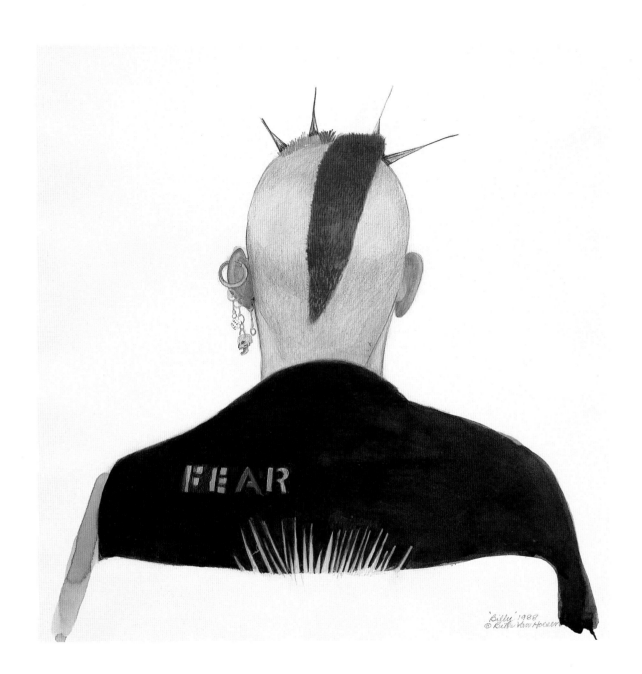

Billy

1988

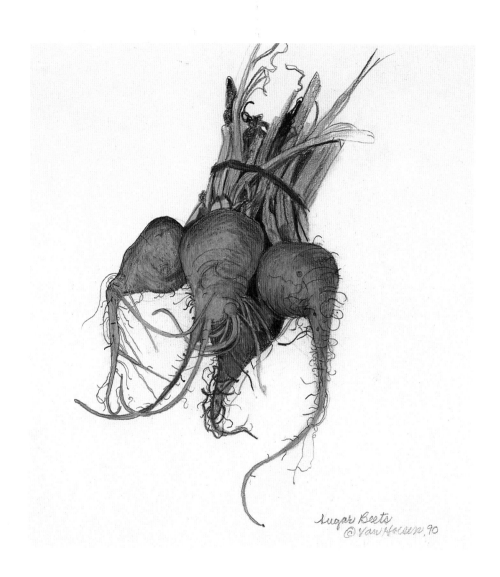

Sugar Beets

1990

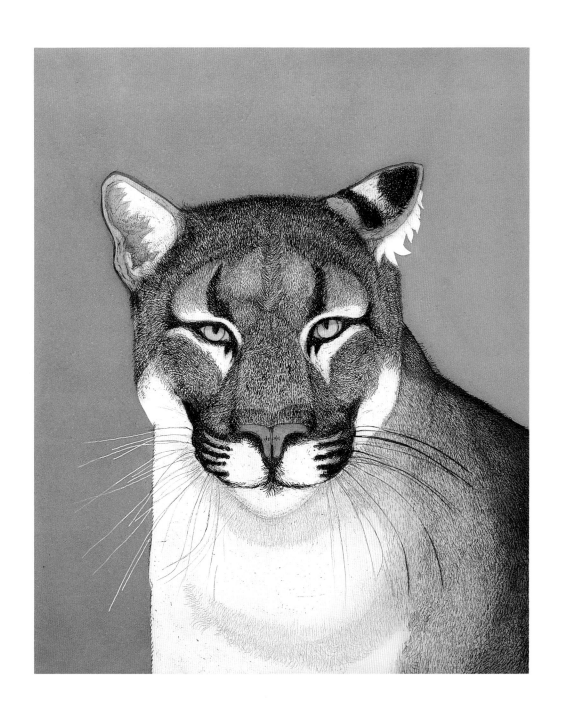

Maharani

1988

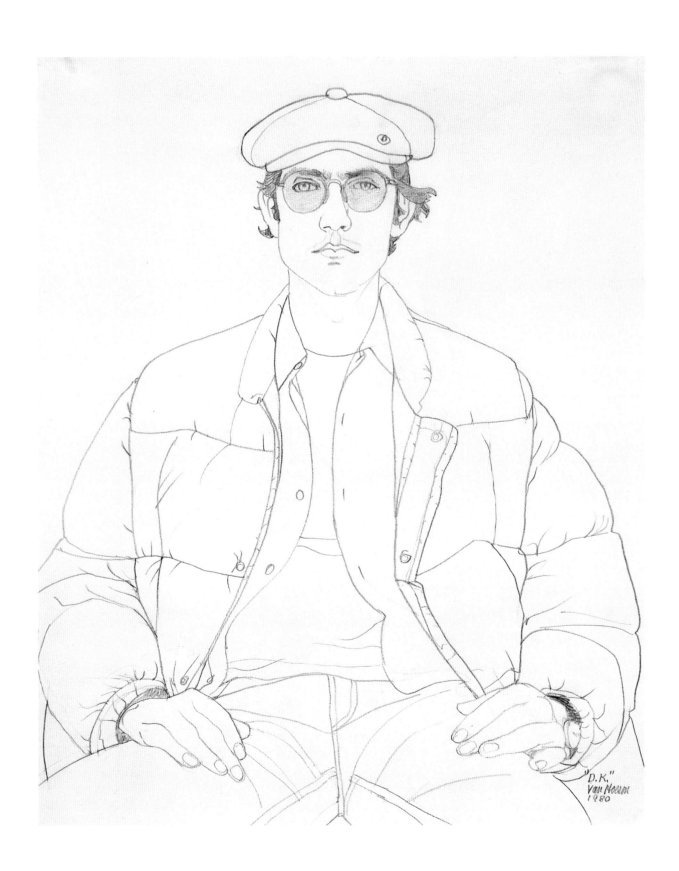

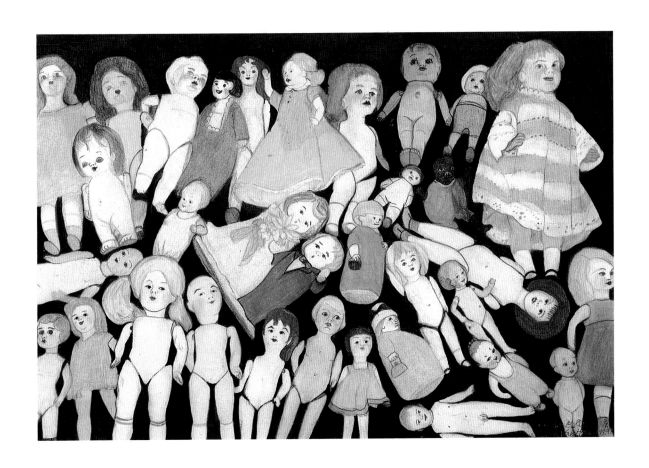

D. K. China Dolls

1980 1991

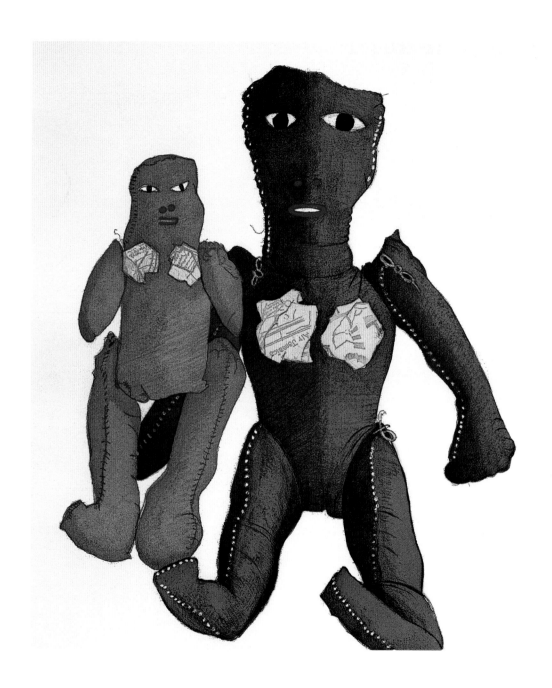

Haitian Dolls

1991

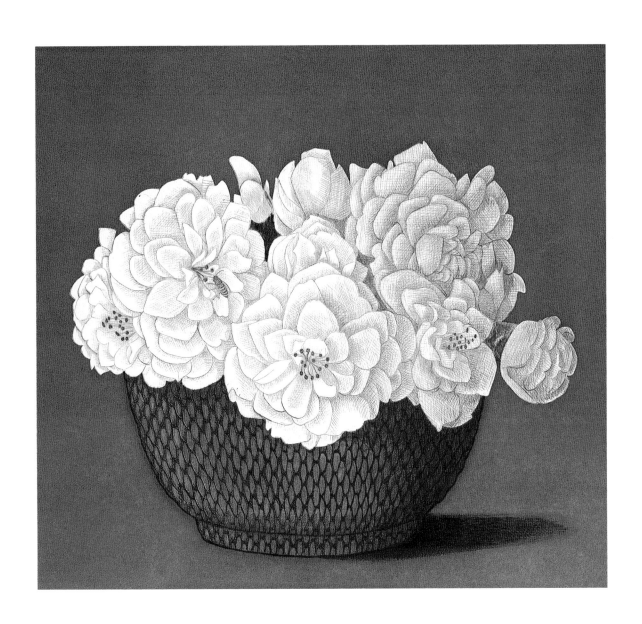

Basket of Camellias

1991

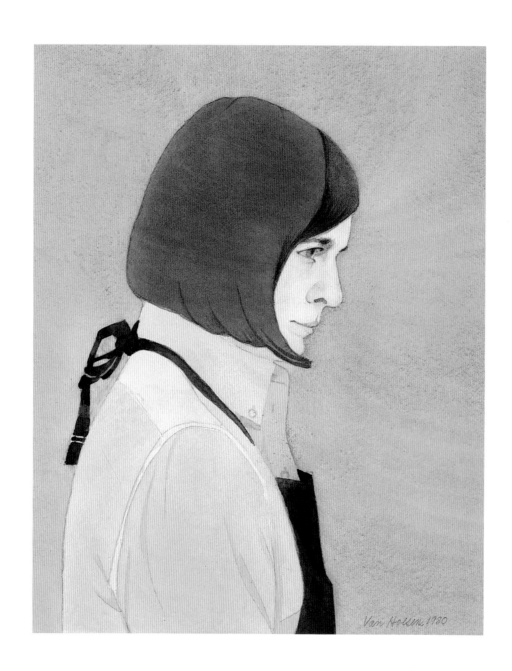

Beth

1980

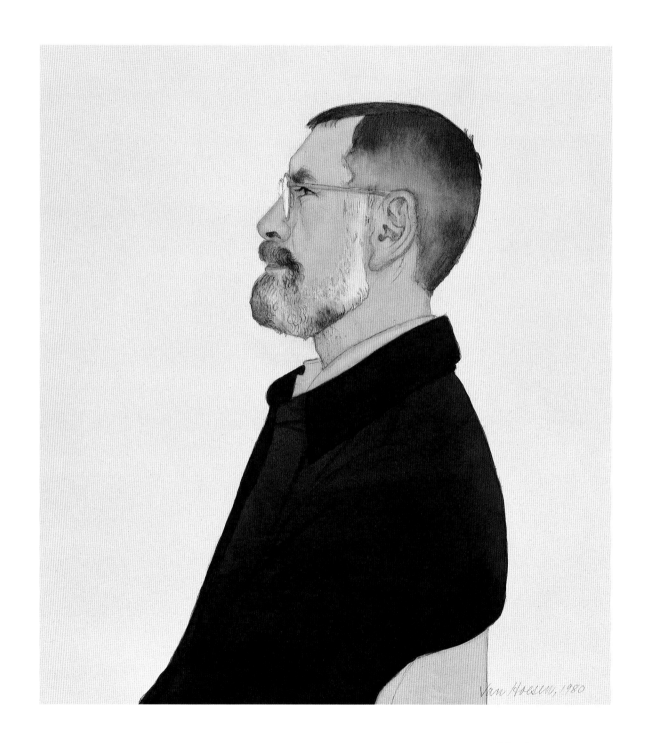

M. A.

1980

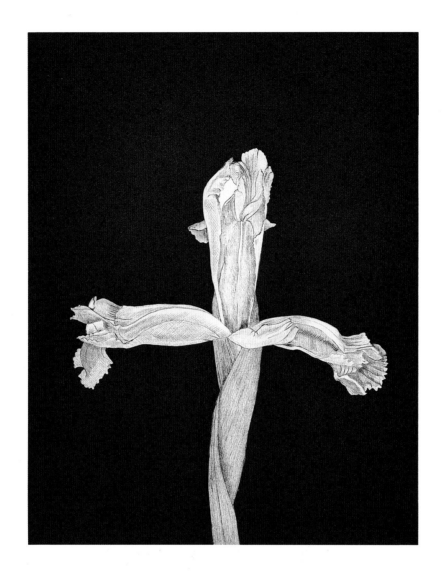

White Iris

1975

Bouquet with Lilies

1988

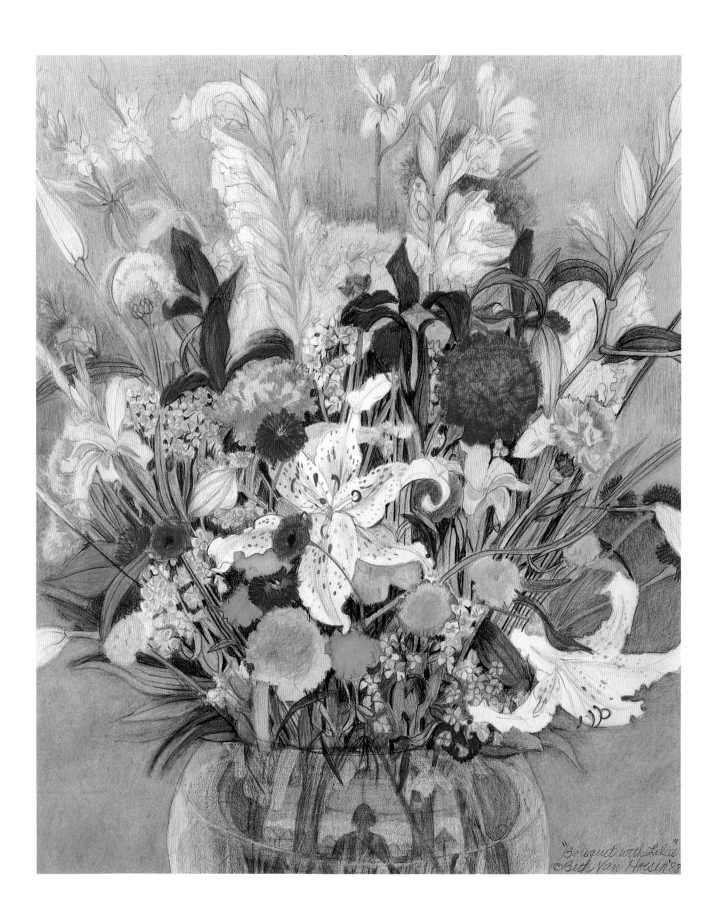

"Bouquet with Lilies"
Beth Van Hoesen '88

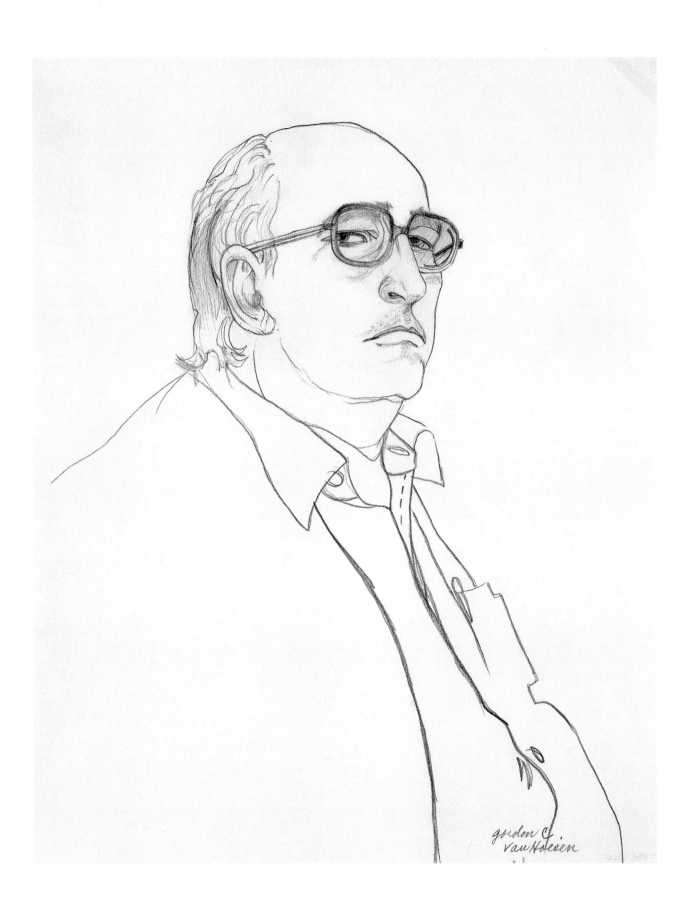

gordon
van Hoesen

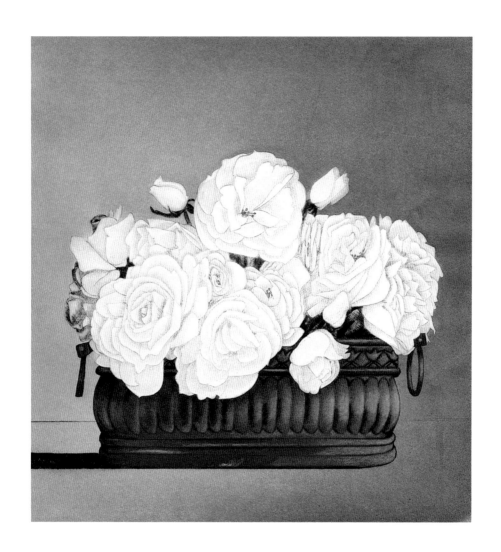

Gordon C.

1981

Karen's Roses

1980

Checklist

All dimensions are given in inches, height preceding width. Unless otherwise noted, all works are on paper.

Print listings include the name of the press or individual who printed the edition. When more than one name is listed, the first assisted the artist in making the plate(s) and the second printed the edition.

Page 6
Profile, 1960
Edition of 25
Etching, 6½ × 8⅝
Jeryl Parker

Page 11
Concierge, ca. 1949
Oil on board, 18 × 15
Collection of the artist

Page 13
Yearbook, 1958
No edition
Etching, aquatint, 9¾ × 6½

Page 15
Back, 1965
From *The Nude Man* suite
Edition of 50
Engraving, 8¾ × 4
Crown Point Press

Page 16
Seated, 1965
From *The Nude Man* suite
Edition of 50
Engraving, 6⅞ × 5⅛
Crown Point Press

Page 19
Sally, 1979
Edition of 100
Drypoint, etching, aquatint, 11⅝ × 13¾
Katherine Lincoln Press/Made in California

Page 23
St. Honoré Cake, 1985
Watercolor, color pencil, 12 × 13
Private Collection, San Francisco

Page 24
Theo, 1980
Graphite, 17 × 14
Collection of John Modell,
San Francisco

Page 25
Hau Blossom, 1979/92
Color pencil, 8¼ × 10¼
Private Collection, San Francisco

Page 26
Jan's Doll, 1990
Edition of 27
Aquatint, etching, drypoint, 10⅞ × 9
Teaberry Press/Jennifer Cole

Page 27
Squid, 1978
Color pencil, graphite, 6½ × 8¼
Private Collection, San Francisco

Page 28
Sherwood's Rose, 1982
Edition of 50
Aquatint, drypoint, watercolor,
6⅞ × 6¼
Katherine Lincoln Press

Page 29
Jane, 1982
Graphite, 16¼ × 13⅝
Van Hoesen/Adams Collection,
San Francisco

Page 30
Chocolate Truffles, 1982
Color pencil, graphite, 13 × 12¾
Private Collection, San Francisco

Page 31
Bowl of Roses, 1979
Edition of 100
Aquatint, drypoint, etching, 11¼ × 10⅞
Katherine Lincoln Press

Page 32
Filoli Rose, 1980
Color pencil, 13¼ × 16½
Private Collection, San Francisco

Page 33
Pike, 1988
Edition of 25
Drypoint, etching, watercolor,
13¾ × 16⅞
Teaberry Press

Page 34
Brussels Sprouts, 1980
Ink, 22½ × 17½
Private Collection, San Francisco

Page 35
Michiko, 1991
Color pencil, watercolor, ink,
14⅛ × 11½
Private Collection, San Francisco

Page 36
Oregon Doll Museum, 1991
Color pencil, graphite, 13¾ × 15
Courtesy John Berggruen Gallery,
San Francisco

Page 37
Bird of Paradise in Concrete, 1981
Graphite, color pencil, 16¾ × 13¾
Collection of Mark Adams,
San Francisco

Page 38
Bay Boats, 1988
Edition of 35
Aquatint, drypoint, etching,
watercolor, 14 × 17½
Teaberry Press

Page 39
Heidi, 1987
Graphite, 21¼ × 14⅛
Private Collection, San Francisco

Page 40
Albert's Poppies, 1991
Edition of 50
Aquatint, etching, drypoint, 16 × 16¼
Teaberry Press/Katherine Lincoln Press

Page 41
Noni, 1978
Color pencil, graphite, 7⅝ × 5¾
Private Collection, San Francisco

Page 42
Pocketbook Vase, 1991
Color pencil, 15¼ × 12⅞
Collection of Mary and Carter
Thatcher, San Francisco

Page 43
Cold in Aswan, 1964
Graphite, 19⅛ × 13¾
Collection of Mark Adams,
San Francisco

Page 44
Mynderse, 1968/80
Edition of 50
Etching, drypoint, engraving, 14½ × 11⅛
Made in California

Page 45
Bowl of Hydrangeas, 1979
Edition of 100
Aquatint, drypoint, watercolor,
13½ × 13⅞
Katherine Lincoln Press

Page 46
Dürer Can, 1982
Edition of 70
Aquatint, drypoint, etching,
watercolor, 15⅞ × 13¼
Teaberry Press/Robert Townsend

Page 47
Jan's Squash, 1982
Color pencil, 14¼ × 14¼
Collection of Jan and Bruce
MacDonald, Los Gatos, California

Page 48
Baby Girl Young, 1983
From *Newborns* suite, vol. II
Edition of 15
Drypoint, 5⅛ × 4½
Teaberry Press

Page 48
Baby Boy Eaton, 1983
From *Newborns* suite, vol. II
Edition of 15
Drypoint, 6¼ × 5⅛
Teaberry Press

Page 48
A & B Ferree, 1983
From *Newborns* suite, vol. I
Edition of 15
Drypoint, 6⅞ × 9
Teaberry Press

Page 49
Matthew, 1992
Edition of 20
Drypoint, watercolor, 7⅞ × 8
Teaberry Press

Page 50
Peony, 1975/76
From *Poppies and Peony* suite
Edition of 40
Aquatint, drypoint, etching, engraving,
17¾ × 14⅛
Crown Point Press

Page 51
Flo, 1973
Edition of 25
Aquatint, drypoint, watercolor, 9 × 8⅞
Gwen Gugell

Page 52
Bouquet with Iris, 1988
Acrylic, color pencil, watercolor,
22¼ × 19¼
Collection of Mr. and Mrs. Robert
Halperin, Atherton, California

Page 53
Tiger, Archie and Spencer, 1987
Color pencil, graphite, 9½ × 11¾
Collection of Mrs. Gail Overaa,
Lafayette, California

Page 54
Sylvi, 1978
Edition of 25
Engraving, 10¾ × 13⅞
El Dorado Press

Page 55
Little Poppies, 1975/80
Edition of 25
Aquatint, etching, drypoint,
watercolor, 10½ × 10¾
El Dorado Press

Page 56
Lily, 1981
Watercolor, color pencil, 19⅜ × 19¼
Mr. and Mrs. William Janss, Sun Valley,
Idaho

Page 57
Lisza, 1982
Color pencil, graphite, 21¾ × 14
Private Collection, Berkeley, California

Page 58
Russell's Cabbage, 1986
Graphite, 13 × 13
Collection of the artist

Page 59
$24 Orchids, 1988
Color pencil, graphite, 16⅝ × 17⅞
Courtesy John Berggruen Gallery,
San Francisco

Page 60
Angelika's Cookies, 1989
Color pencil, graphite, 10⅝ × 13
Collection of George and Judy Marcus,
Los Altos Hills, California

Page 61
Hologram Glasses, 1990
Edition of 25
Aquatint, drypoint, 7¼ × 7¾
Teaberry Press

Page 62
Flowers, Flowered Vase, 1992
Edition of 52
Lithograph, 22¼ × 17¼
Trillium Graphics

Page 63
Flowers, White Vase, 1993
Edition of 52
Lithograph, 21¾ × 16⅝
Trillium Graphics

Page 64
Dr. K, 1968
Graphite, 19 × 12½
Van Hoesen/Adams Collection,
San Francsico

Page 65
Fungi, 1982
Edition of 30
Aquatint, drypoint, engraving,
watercolor, 10⅝ × 11⅛
Teaberry Press/Made in California

Page 66
Fresno Basket, 2nd state, 1984
Edition of 15
Aquatint, drypoint, etching,
watercolor, 12½ × 12¾
Made in California

Page 67
Begonias in Lunch Box, 1991
Color pencil, 9½ × 10
Collection of Mr. Alex Mehran,
San Francisco

Page 68
Haemanthus, 1990
Graphite, 15¾ × 14
Private Collection, San Francisco

Page 69
David S., 1977
Watercolor, 15 × 11⅝
Collection of David Salgado, Alameda,
California

Page 70
Silver Cup, 1978
Edition of 15
Drypoint, watercolor, 10¾ × 6⅛
El Dorado Press

Page 71
Strawberry Cake, 1988
Graphite, color pencil, 21 × 19¾
Collection of Andrea and Peter Klein,
Long Island, New York

Page 72
Traci, 1990
Edition of 50
Aquatint, etching, drypoint, 9⅝ × 8¾
Made in California

Page 73
Steve, 1988
Graphite, ink, acrylic, watercolor,
19 × 17½
Van Hoesen/Adams Collection,
San Francisco

Page 74
Edible Roots, 1990
Edition of 25
Etching, drypoint, 8⅜ × 8⅞
Made in California

Page 75
Oka, 1991
Edition of 30
Aquatint, etching, drypoint,
watercolor, 12 × 9
Teaberry Press

Page 76
Poppy in Hand, 1975/76
From *Poppies and Peony* suite
Edition of 40
Aquatint, etching, watercolor,
14¾ × 13⅞
Crown Point Press

Page 77
Matilija Poppy, 1975/76
From *Poppies and Peony* suite
Edition of 40
Aquatint, drypoint, 13⅝ × 12½
Crown Point Press

Page 78
Jim Kantor, 1986
Graphite, 14¾ × 12½
Private Collection, San Francisco

Page 79
Park Cyclamen, 1988
Edition of 40
Aquatint, drypoint, watercolor,
11⅝ × 14¼
Hirsh-Greene Printers

Page 80
Pan of Carrots, 1989
Color pencil, 10½ × 10⅜
Collection of George and Judy Marcus,
Los Altos Hills, California

Page 81
Billy, 1988
Watercolor, color pencil, 19⅜ × 19¼
Private Collection, San Francisco

Page 82
Sugar Beets, 1990
Color pencil, graphite, 13 × 11½
Courtesy John Berggruen Gallery,
San Francisco

Page 83
Maharani, 1988
Edition of 50
Aquatint, etching, 15¼ × 12⅞
Teaberry Press

Page 84
D. K., 1980
Graphite, 16⅞ × 13⅞
Private Collection, San Francisco

Page 85
China Dolls, 1991
Color pencil, graphite, 11¼ × 16½
Courtesy John Berggruen Gallery,
San Francisco

Page 86
Haitian Dolls, 1991
Edition of 50
Aquatint, etching, watercolor, 11¼ × 10
Made in California

Page 87
Basket of Camellias, 1991
Edition of 50
Aquatint, drypoint, 9½ × 10½
David Kelso/Teaberry Press

Page 88
Beth, 1980
Watercolor, 10¾ × 8¾
Van Hoesen/Adams Collection,
San Francisco

Page 89
M. A., 1980
Watercolor, 11⅞ × 9¾
Collection of The Fine Arts Museums of
San Francisco, Achenbach Foundation
for Graphic Arts, Hamilton-Wells Fund

Page 90
White Iris, 1975
Edition of 25
Aquatint, drypoint, 14½ × 10
El Dorado Press

Page 91
Bouquet with Lilies, 1988
Acrylic, color pencil, watercolor,
23¼ × 19⅛
Collection of Jacqueline McAbery,
Mill Valley, California

Page 92
Gordon C., 1981
Graphite, 16½ × 13½
Private Collection, San Francisco

Page 93
Karen's Roses, 1980
Edition of 30
Aquatint, drypoint, watercolor,
11⅜ × 10⅞
Katherine Lincoln Press/Made in
California

Biography

Beth Van Hoesen was born in Boise, Idaho, in 1926.

She attended the following schools: Stanford University, B.A., 1944–48; Escuela Esmeralda, Mexico, 1945; California School of Fine Arts, 1946, 1947, 1951, 1953; Ecole des Beaux-Arts de Fontainbleau, France, 1948; Académie Julian and Académie de Grande Chaumière, Paris, 1948–50; San Francisco State College, 1957, 1958.

She married artist Mark Adams in 1953. They live in a converted 1909 firehouse in San Francisco, California.

Selected Solo Exhibitions

Lucien Labaudt Art Gallery, San Francisco, California, 1952

Stanford University Art Gallery, Stanford, California, 1957; 1983: *Beth Van Hoesen: Prints and Drawings* (poster)

M. H. de Young Memorial Museum, San Francisco, California, 1959

California Palace of the Legion of Honor, Achenbach Foundation for Graphic Arts, San Francisco, 1961: *Beth Van Hoesen*, traveling exhibition (catalogue); 1962: travel to Boise Gallery of Art, Idaho; Santa Barbara Museum of Art, California; IBM Corp., San Jose, California; 1974: *Beth Van Hoesen* (catalogue)

San Francisco Museum of Art, California, 1965

Felix Landau Gallery, Los Angeles, California, 1966

E. B. Crocker Art Gallery, Sacramento, California, 1966

Hansen-Fuller Gallery (later Fuller-Goldeen), San Francisco, California, 1966, 1977, 1980

San Diego State University, California, 1967: *The Eloquence of the Line, Prints by Beth Van Hoesen*

Walnut Creek Arts Gallery, California, 1969

Fountain Gallery, Portland, Oregon, 1967: *Favorite Prints by Beth Van Hoesen;* 1984: *Prints by Beth Van Hoesen*

Smith Anderson Gallery, Palo Alto, California, 1971, 1974

Mt. Angel Abbey, Oregon, 1971

Rio Hondo College, Whittier, California, 1972

University of Idaho, Moscow, 1973

College of Idaho, Jewett Exhibition Center, Caldwell, 1973

Contemporary Graphics Center of the Santa Barbara Museum of Art, California, 1974

Young Gallery, San Jose (later Saratoga), California, 1979, 1981, 1983, 1986

Oakland Museum, California, 1980: *Beth Van Hoesen—Prints, Drawings, Watercolors* (catalogue)

John Berggruen Gallery, San Francisco, California, 1982 (catalogue), 1985, 1988, 1991

Art Museum Association of America, 1983–85: *Beth Van Hoesen: Prints, Drawings, Paintings,* traveling exhibition (catalogue). Travel to de Saisset Museum, University of Santa Clara, California; El Paso Art Museum, Texas; Fresno Arts Center and Museum, California; Kaiser Center, Oakland, California; North Dakota State University, Fargo; The Haggin Museum, Stockton, California; Scottsdale Center for the Arts, Arizona; Boehm Art Gallery,

Palomar College, San Marcos, California; Kittredge Gallery, University of Puget Sound, Tacoma, Washington; Missouri Botanical Garden, St. Louis

Stanford University, California, 1983: *Beth Van Hoesen: Prints and Drawings* (poster)

Arizona State University Art Collections, Tempe, 1984: *Wonderful Animals of Beth Van Hoesen*

Palo Alto Cultural Center, California, 1987: *Selections from Beth Van Hoesen: Creatures*

Himovitz-Jenson Gallery, Sacramento, California, 1988: *Beth Van Hoesen: Contemporary Realist*

Jane Haslem Salon, Washington, D.C., 1988: *Beth Van Hoesen: Creatures, Flowers and Figures*

First Impressions Gallery, Carmel, California, 1990: *Beth Van Hoesen: Recent Work*

Stanford University, California, Faculty Club, Institute for Research on Women and Gender, 1991: *Beth Van Hoesen*

Himovitz-Miller Gallery, Sacramento, California, 1991: *Beth Van Hoesen*

North Point Gallery, San Francisco, California, 1993: *Beth Van Hoesen: Intaglio Prints*

Selected Group Exhibitions

California State Fair Art Exhibition, Sacramento, 1951 (award), 1952, 1958, 1959, 1960, 1961

Library of Congress, Washington, D.C., 1956, 1957

San Francisco Museum of Modern Art, California, 1951; 1952; 1953; 1954; 1956 (award); 1957; 1958; 1959 (award); 1960; 1961 (award); 1962; 1964; 1965; 1967; 1970 (award); 1985; 1986: *Moses Lasky Collection;* 1986: *American Realism: Twentieth-Century Drawings and Watercolors* (catalogue)

California Palace of the Legion of Honor, Achenbach Foundation for Graphic Arts, San Francisco, 1951, 1958, 1959, 1960, 1961 (award), 1964, 1965 (award), 1966, 1976, 1977, 1979, 1981

Philadelphia Sketch Club, Pennsylvania, 1957

Oakland Museum, California, 1958; 1960; 1974 (award); 1975 (award); 1987: *Cream of California Prints* (brochure)

American Federation of Arts, 1963: *Some Images of Women,* traveling exhibition

U.S. State Department, Art in Embassies, 1966–68

Honolulu Academy of Arts, Hawaii, 1959, 1970, 1971 (award), 1973, 1975, 1980 (award)

Museum of Fine Arts, Boston, Massachusetts, 1959, 1960, 1962

Pennsylvania Academy of the Fine Arts, Philadelphia, 1959, 1960, 1963, 1965

Northwest Printmakers International Exhibitions, 1962, 1963: Seattle Art Museum, Washington; Portland Art Museum, Oregon,

Brooklyn Museum, New York, 1962; 1965: *Amerikanische Radierungen,* sponsored by Brooklyn Museum, travel through Germany; 1966; 1968; 1977

M. H. de Young Memorial Museum, San Francisco, California, 1956, 1963, 1964

Pasadena Art Museum, California, 1964 (purchase award)

Norfolk Museum of Arts & Sciences, Virginia, 1965, 1970

World Exposition, Osaka, Japan, 1970

Fine Arts Gallery of San Diego, California, 1967, 1971, 1977

Impressions Workshop, Boston, Massachusetts, 1977: *West Coast Prints*

Smith-Anderson Gallery, Palo Alto, California, 1977: *Adams, Cook, Van Hoesen: Works on Paper*

San Francisco Art Institute, California, 1972 (catalogue)

Mills College Art Gallery, Oakland, California, 1978, 1983

Pratt Manhattan Center Gallery, New York, 1980

University of Massachusetts, Amherst, 1980

Tahir Gallery, New Orleans, Louisiana, 1981: *American Women Artists*; 1983; 1986

De Saisset Museum, University of Santa Clara, California, 1983: *Bon à Tirer—Fine Arts Presses*
 of the Bay Area

Susan Blanchard Gallery, New York, New York, 1983

Charles Campbell Gallery, San Francisco, California, 1983: *Five San Francisco Artists*; 1986:
 Life Drawing—1980's: Seven San Francisco Artists (catalogues)

Corpus Christi State University, Texas, 1983: *Creatures in Print*

Port of History Museum, Philadelphia, Pennsylvania, 1983: *Printed by Women*

The Print Club, Philadelphia, Pennsylvania, 1983: *Choice Prints: Recent Prints by Various Artists*

Modernism Gallery, San Francisco, California, 1984: *California Drawings*

Portland Art Museum, Oregon, 1985

Orr's Gallery, San Diego, California, 1983: *Contemporary American Realists*

World Print Council, 1984–86: *Prints U.S.A.*, traveling exhibition (catalogue)

Glastonbury Gallery, San Francisco, California, 1983: *A Selection of Contemporary Drawings*; 1985:
 The Small Press Phenomenon: Work from 18 Bay Area Fine Art Presses

Transamerica Pyramid, San Francisco, California, 1985: *A City Collects*

University of Tennessee, Chattanooga, 1985: *Two California Artists: Mark Adams/Beth Van Hoesen.*
 Travel to La Grange College, Georgia

William Sawyer Gallery, San Francisco, California, 1985: *American Realism*

Fresno Arts Center and Museum, California, 1986: *In the Advent of Change: 1945–1969*

Steven Wirtz Gallery, San Francisco, California, 1988: *Flo Allen: A Model for a Generation*

Santa Rosa Junior College Art Gallery, California, 1988: *National Drawing Exhibition*

C. N. Gorman Museum, University of California, Davis, 1988: *The Tracks of Human-Animal*
 Relationships

Jane Haslem Salon, Washington, D.C., 1988: *Consonance* (catalogue)

Arizona State University, Tempe, 1989: *Sixty Years of American Printmaking: 1930 to the Present*

American Embassy, Sarajevo, Yugoslavia, 1989: *Novija Americka Grafika*

New Orleans Museum of Art, Louisiana, 1990: *With Nothing On*

Jane Haslem Salon, Washington, D.C., 1991: *American Self-Portraits in Prints*

John Berggruen Gallery, San Francisco, California, 1991: *Small Format Works on Paper*

Ewing Gallery of Art and Architecture, University of Tennessee, Knoxville, 1992: *Teaberry Press:*
 The Intimate Collaboration. Traveling exhibition (catalogue)

Palo Alto Cultural Center, California, 1992–1993: *Directions in Bay Area Printmaking: 3 Decades*

Books and Publications

"Beth Van Hoesen: One-Woman Renaissance in Prints," *Esquire* (August 1955): 78–79.

"A Portfolio by Beth Van Hoesen," *Ramparts* 3 (1964): 40–58.

A Collection of Wonderful Things, Intaglio Prints by Beth Van Hoesen. San Francisco, California: Scrimshaw Press, 1972.

Threepenny Review (Spring 1985). Fourteen prints reproduced.

California Fresh Cookbook. Foreword by M. F. K. Fisher. Oakland, California: The Junior League of Oakland–East Bay, 1985. Sixteen prints and drawings reproduced.

Beth Van Hoesen Creatures: The Art of Seeing Animals. Foreword by Evan Connell. San Francisco, California: Chronicle Books, 1987. French edition published by Flammarion, 1988. Prints, drawings, and watercolors.

Connor, Celeste. "Beth Van Hoesen: The Art of Beholding," *Women's Studies* 22 (1992): 83–98.

Special Awards

City of San Francisco. Award of Honor in Graphics, 1981

California Society of Printmakers. Distinguished Artist Award, 1993

Lectures, Workshops, Juries

Fresno Arts Center and Museum, California. Lecture, 1983

Mendocino Art Center, California. Lecture and drawing workshop, 1983

Haggin Museum, Stockton, California. Juror, 1983

Peninsula Art Association, San Mateo, California. Juror, 1983

Marin Society of Artists, California. Juror, 1983

California State Fair, *California Work, 1986.* Juror, 1986

Fresno Arts Center and Museum, California. Juror, catalogue essay, 1986

San Francisco Women Artists, *Tri-Media Show.* Juror, 1988

California Society of Printmakers. Panelist, 1992

Selected Public Collections

Achenbach Foundation for Graphic Arts, San Francisco, California

Art Institute of Chicago, Illinois

Brooklyn Museum, New York

Cincinnati Art Museum, Ohio

De Saisset Museum, University of Santa Clara, California

El Paso Museum of Art, Texas

Fresno Arts Center and Museum, California

Honolulu Academy of Arts, Hawaii

Mills College, Oakland, California

Monterey Peninsula Museum of Art, California

Museum of Modern Art, New York, New York
Norton Simon Museum, Pasadena, California
Oakland Museum, California
Portland Art Museum, Oregon
Rutgers University Printmaking Studies Archives, New Brunswick, New Jersey
San Francisco City and County
San Francisco Museum of Modern Art, California
San Jose Museum of Art, California
Santa Barbara Museum of Art, California
Smithsonian Institution, Washington, D.C.
Stanford University, California
Triton Museum of Art, Santa Clara, California
U.S. Information Bureau, Washington, D.C.
University of California, Berkeley
University of California, Davis
University of Idaho, Moscow
University of Tennessee at Chattanooga
Victoria and Albert Museum, London, England
Williams College, Williamstown, Massachusetts